Sex Disasters...

And How To Survive Them

by

Charles Moser, Ph.D., M.D.
and Janet W. Hardy

greenery press

Cover: JohnnyInk, www.johnnyink.com

Illustrations: James Kochalka

Published in the United States by Greenery Press, 1447 Park Ave., Emeryville, CA 94608, www.greenerypress.com.

ISBN 1-890159-44-1

Contents

THIS book is dedicated to all our partners, who practiced these Disasters with us.

I can't get this cock ring off!

BEFORE we solve your immediate problem, let's talk to people who aren't in this situation (yet).

First: What is a cock ring, and why would anyone want to wear one? It's a small strap or ring, usually made of leather, rubber or metal. You wear it, *not* around your cock, but around the base of your cock and balls. Some men find that it helps them to maintain an erection (see p. 140). Others simply like the way it feels and looks. The leather ones make cute bracelets, too – you and your fella can go out in public as a "matched set" and nobody's the wiser.

For those who are new to cock ring play, allow us to suggest that you work your way up – start with simple leather straps that fasten with snaps or Velcro, which can be removed with a simple tug. Then, once you know what size works for you, graduate to the rubber O-ring kind, which you could still cut off (carefully) if you

had to. Only when you've got the hang of the rubber ones should you try the steel kind.

But let's suppose that you've done all that, and that whatever you're doing was just so much fun that you've sustained this fabulous erection which is now reluctant to relinquish its pretty steel necklace.

You'd probably rather not have to go to the emergency room right now (although if the erection is *that* impressive, it might do wonders for your social life). Instead, you want to try to figure out ways to reduce the erection yourself. Reading your calculus textbook, or thinking about what your boss must look like naked, may or may not work.

If it doesn't, try greasing yourself up with mineral oil, and don't be stingy. Or hop in the shower and turn the water on ice-cold, which will probably make Mr. Happy a little bit sadder. Lather up with plenty of soap – not too enthusiastically, or you'll make the problem worse – and with any luck at all, you'll be able to slide the ring right off.

If you're still stuck, head for the emergency room. The doctor might do nasty things with needles that you don't want to think about right now. (Or maybe you do – we have no illusions about who might read this book.) Actually, she'll probably withdraw some blood from your cock with a syringe, and inject a type of Neo-Synephrine™, which will reduce your erection enough to remove the ring. Maybe you'd like to try that cold shower again.

An erection, cock-ring-induced or not, that lasts more than four hours requires an immediate emergency room visit. If the blood clots inside your cock, for whatever reason, you will not enjoy the results.

My girlfriend and I were making out and her Doberman snarled at me!

SINCE we're not prepared to recommend that all our readers carry Milk-Bones™ in their pockets at all times, we turned to our friend Pat the Vet for advice on this one. She says:

"Dogs are social and sexual animals. They should not transfer doggie relations to humans, but some never learned that in doggie school. What that means is that a dog who takes excessive personal interest in a human, whether aggressive or sexual, is moving outside the normal canine psychosocial limits. An owner who takes an easygoing, 'get used to it' approach to this kind of behavior had better enjoy the dog's company a lot, because he's not going to be getting much of anybody else's company." She notes that if the dog has been intrusive during common hugs and giggles, it is not going to be passive during the excitement of, um, more intense passions.

The best plan, she says, is to simply shut the mutt out while you and your squeeze get busy. "But often, by the time you remember to do that, it's too late." So try to remember to get the pooch comfortably situated before any unhappiness (his) or happiness (yours) occurs.

She goes on to explain that any dog showing any significant personal interest in your sweeties – whether as potential leg-humping buddies or as potential competitors – must be immediately and firmly dissuaded. You do this by preventing Spot from freely choosing to interact with the object of your affections.

For example: the fire of your loins rings the front doorbell. Spot does not get to be the greeter; he must sit to one side while you say hello in whatever way works for the two of you, and only then does he get his turn. If your pooch doesn't obey well enough to stay put while you're greeting your snoogie-oogums, put him in his crate or in another room.

Does it need to be said here that Spot shouldn't sleep in your bed, and especially not between the two of you? Let's not give him

(or you) any ideas – we have qualms about including our canine friends in any kind of play that doesn't involve fetching sticks.

And none of that pawing or head-bumping either – aggressive dogs should not be allowed to solicit attention. Spot must wait until your sweet patootie initiates contact, not the other way around.

If it looks like this could be the start of something big, it's time to start teaching Spot to accept your new partner as the boss. For a while, he or she should become the source for meals, treats, walks and All Things That Make A Dog's Life Worth Living. Pat suggests, "There are numerous trainers available and many books that discuss realigning a dog's social relationships; Carol Benjamin's books and The *Monks of New Skete* books are the ones I recommend first to folks with behavioral questions regarding dogs."

How To Put On A Condom

Unless you went to an extremely enlightened school, chances are you learned how to put on a condom either by trial and error or from a partner. We suggest you try our way – there may be a tip or two in here you haven't hit on yet.

The first and most important thing is to understand how your dick receives sensation inside the condom. Most of us expect to feel the friction of our dick against the inside of our partner's pussy, asshole, or mouth. If that's what you're waiting to feel, you're likely to wind up pretty frustrated – it's that expectation that leads to the "taking a shower in a raincoat" complaint expressed by many men during their first condom experience.

The actual sensation of sex with a condom comes from

6

the friction of your dick against the inner surface of the condom, which is being moved up and down by its contact with the inside of your partner's delightful orifice. So if you're going to learn to enjoy condom use, your best bet is to maximize that movement – without losing the condom.

The ideal condom, then, is one that fits comfortably tightly around the base of your dick but more loosely around its head, so there's enough motion to keep you stimulated. One particular brand of condom is many folks' favorite because it's designed with a "pouch" area on the underside of the dick for exactly that reason.

You wouldn't be comfortable in a suit that didn't fit, and you won't feel comfortable or happy or sexy in a condom that doesn't fit. Condoms are designed with a variety of shapes, textures and sizes – try a variety of brands to find your best fit. Big is not necessarily the best size for everyone, so don't let your ego get in the way of reality. Some people like ridges, bumps and other frills; others don't. Some enjoy the flavored kind; others find them kind of gross.

Masturbating with a condom on is a good way to "test drive" different brands and techniques, as well as good practice in getting the thing on smoothly and properly... which we suggest you do as follows:

- Make sure you're as erect as it's possible for you to be at this point in time. Many men find that the fuss of putting on a condom can cause their erection to wilt, which is why we recommend solo practice so that the action is smoother and more familiar. If your partner is the one putting on the condom, ask him or her to continue stimulating you throughout the process.

- Figure out which way it unrolls. You can do this by unrolling it by one-quarter to one-half of an inch.

- Place one drop of *water-based* lubricant inside the condom, at the center of the end. The lube helps the condom slide around on the head of your dick and increases the sensation. It also helps conduct heat from your partner's body, which is generally a Good Thing.

- Pinch up the half inch or so you unrolled to make a "reservoir" at the end. You can try this technique even if you're using a condom with a reservoir tip – having this extra bit of latex at the end gives a little more room for movement.

- With one hand holding the tip of the condom at the tip of your dick, use the other hand to smoothly roll the condom downward all the way to the base of your dick. (Be careful that the reservoir tip, if it has one, doesn't get stretched over the head of your cock.) The motion is basically the same one that most men use to masturbate – making an "O" of the thumb and index finger and moving it up and down the penis – except that you use more friction on the downstroke than the upstroke. It may take you four or five strokes or more to get the condom rolled all the way down. Be careful not to catch any pubic hairs at the base. (For one easy solution to this problem, see p. 33.)

- If you want to be extra safe, or if the condom feels at all loose at the base, keep one hand on the base of your penis to hold it in place while you proceed with

sex – just don't get so preoccupied that it decreases your enjoyment.

- Apply more of the water-based lubricant to your partner's pussy or asshole, and/or to the outside of the condom. Mouths have saliva and don't need lube (unless you like the taste of lube, which we don't).

- Afterwards, don't try to roll it back up. Pull the base of the condom away from the base of your penis, hooking your finger between the rubber and the skin, and pull it gently up your dick, being careful not to spray semen everywhere. Tie a knot in the end, keeping the semen inside, and throw it over your left shoulder for luck.

- Discard it appropriately. Flushing it is hard on the plumbing, so don't. It's a nice touch to wrap it in some toilet paper or a paper towel so your partner doesn't have to look at it in the wastebasket. Please don't drop it on the ground, even if you're in a public space. Although you probably don't need to be concerned about the pathogens on the outside of the condom – HIV and most other STDs are very fragile , and even hepatitis B isn't really a risk unless you touch it with a mucous membrane or an open sore – stepping barefoot on a used condom is extremely unpleasant (used condoms beat banana peels in slipperiness every time). If the condom has been used for anal play, it's contaminated, and should be disposed of in the same way you'd dispose of anything soiled with fecal matter – we like to wrap it in toilet paper, then drop it into a leftover peanut butter jar or something

else with a screw-on or snap-on top, then throw the whole thing away.

- Even if you're not the one on the receiving end of the condom, experiment with these techniques so you can help your partner get the condom on and off. Some popular condom users have learned to apply condoms with their mouths – we suggest some practice with a box of rubbers and a cucumber, or the appropriate sex toy.

If you prefer polyurethane (non-latex) condoms, the technique is basically the same. Some think that these condoms, which aren't stretchy like latex, may be extra-susceptible to tearing; others think they're stronger. We're working on the double-blind placebo-controlled study and we'll get back to you as soon as we find enough people who want to have sex with us. Either way, you can't go wrong using plenty of lube. Unlike latex, polyurethane doesn't dissolve in oil, so you can use oil-based lubes like vegetable oil, Crisco™ or coconut oil with these condoms if you like – they can be great for anal play, although we don't recommend the use of oil-based lube inside a vagina.

But, officer, it's just a *little* sex party...

WHETHER you're giving a swing party, an orgy, a BDSM play party, a tantric ritual, or any other kind of event where more than two people are gathering to engage in consensual erotic behavior, it pays to think ahead.

Our lawyer pal Robyn Friedman notes that most sex parties get busted because of complaints from the neighbors. "Let your neighbors know that you're having a party that night, and ask them to call you – not the cops – right away if there are any problems with parking or noise. Then, make sure to tell your guests where they can park so as not to disturb neighborhood activity. Oh, and don't forget to remind them to wear conventional clothing to get from their car to your house."

It may also be a good idea, she adds, to contact your local precinct to let them know that you're planning a party, and to ask them to call you if they get any complaints.

The next thing you need to do is set up your party so that it *looks* like a party. ("Nobody throws abuse parties," Robyn notes.) Put balloons on the front door, hang streamers. Speakers on the front porch with not-too-loud music establish a party atmosphere while helping to muffle any noises from within.

If possible, don't collect money at the party – particularly if you give parties as regular events. You can collect money ahead of time using PayPal or a similar service. If you must collect money at the door, put it into a box or can labeled "cleaning fund" or "snack

fund" so that you can have a valid defense against prostitution or "running a bawdy house" charges.

Designate one person to answer the door, and make sure that person is dressed conventionally. Insist that nobody but you, or your designated doorperson, be allowed to answer the door. Keep the door locked when nobody is using it.

Make it clear to all your guests that illegal drugs will not be tolerated, and that anybody who gets too intoxicated to have good judgment will receive a permanent invitation to the outside world.

Make sure all your guests have a list of the party rules beforehand. Alerting someone to the "street clothes only while outside" rule won't do much good after they've arrived at your front door clad in a jockstrap and pasties.

If at all possible, keep the area in which sexual activities are taking place out of the line of vision from the front door – sometimes a shoji screen, or even a hanging sheet, can help. You might want to designate rooms with windows facing the street or neighboring windows as "quiet rooms," and ask your guests to do their noisier activities in rooms where sound won't carry as easily.

Done all this, and the cops are still at your door? See p. 64.... and good luck.

She was the best-looking woman at the nightclub... until I got her home. Then it turned out she wasn't a woman at all.

BEFORE we start explaining some good ways for you to handle this, let's talk about some *bad* ways. Questioning your own sexuality is a bad way. Taking it personally is a bad way. Getting violent is a very bad way (although a great way to wind up in jail, which would be the right place for you). We're pretty sure you already know all this.

On the other hand, discovering that Ms. Right is actually Mr. Right can be a strain on the *savoir faire* of even the most open-minded lover.

Therapist Dossie Easton told us, "This happened to me once. I thought I was flirting with a tall, gorgeous Amazon. Knowing that tall women sometimes have concerns about their femininity, I spent a lot of time telling her how sexy and womanly she was. My friends were all watching, but they all thought I already knew, and

was being very sensitive in telling my new friend what she most wanted to hear.

"Then I reached under her skirt, and got a big handful of something I wasn't expecting.

"I took a deep breath, and decided that I was relating to the person, not to her genitals – for me, the shape of someone's crotch doesn't change my ethics and obligations toward the rest of the person. So, knowing that transgendered people often have a complicated relationship with their genitals and thus sometimes don't want direct genital stimulation, I cozied up close to her and purred, 'So, honey, tell me exactly what you like best'... and she told me, and we went on from there to have an absolutely wonderful time together."

We think that if we were transgendered, this is exactly the kind of attitude we'd want from our potential partners. But we also recognize that not all of our readers have quite this much flexibility in their outlook. So if you're not quite ready to explore the frontiers of gender, what *do* you do?

First and foremost, be gentle and polite. The situation here is that you're turned off by a potential partner because of an external factor: the shape of her genitals. This is essentially the same situation you'd face if someone you liked a lot had any other physical characteristic that turned you off... cottage cheese thighs or a nasal voice or whatever. And it's not her problem, is it? – it's yours.

So say so. Explain that you really like her, but that you just can't get past this little genital-shape issue. Take responsibility for your own feelings and don't try to blame her for being who she is.

And what if you're just not sure about the whole thing? There's nothing wrong with saying, "This discovery really surprised me, and I'm not sure how I feel about it. Can we talk again in a few days?" Or, as an alternative, "I'm not too sure how I feel about this, but let's try fooling around a little bit to see if it turns us on, and if either of us starts to feel too uncomfortable we can just stop, OK?"

These suggestions, by the way, also apply if you've just discovered that the bulge was a pair of socks.

Remember what Joe E. Brown said at the end of "Some Like It Hot," when he found out that Jack Lemmon was a man under his dress: "Nobody's perfect."

Ewww, look at these sheets!

"**I**S *sex dirty? Only when it's being done right.*" - *Woody Allen, Everything You Always Wanted to Know About Sex, But Were Afraid to Ask, 1972.*

And what that means is that you're frequently going to have to figure out how to get Icky Stains out of your sheets, clothes, lingerie, carpets, drapes, etc., etc....

OK. Adapted from various websites, here are a few suggestions for taking fluids out of fabrics. Most of these suggestions use one or more of the following solutions:

- Detergent solution: one teaspoon of mild pH-balanced household detergent mixed with one cup of water, cool or lukewarm depending on what you're trying to remove.

- Ammonia solution: one tablespoon of household ammonia mixed with half a cup of water (hold your

nose, unless you're into that sort of thing).

- Vinegar solution: one-third cup of white household vinegar mixed with two-thirds cup of water

Any of these solutions should be poured over the stain, then blotted with a clean towel. Kind of a pain, but it beats having cumstains all over your apartment, right?

Semen, otherwise known as a "California potato chip." This one's easy – it's water-soluble and usually doesn't leave color behind. If the stained item is washable, rinse it in cool water, then wash it with regular detergent and enzyme bleach. If we're talking carpets or upholstery or stuff like that, pour a glass of cool water over the stain and blot it with a clean towel. That's probably all you'll need to do – unless, of course, you want to set the stained garment aside for the grand jury.

Although the exact chemical composition of female ejaculate is still being debated, these tips should work for it too. If the ejaculate has a urine smell to it, it might have some urine in it and should be treated as…

Urine. If it's fresh, blot it up, then use ammonia solution, detergent solution, and end by sponging it with clean water and blotting it. If it's dry, do the same thing, but in between the ammonia and the detergent, add another rinse-and-blot using the vinegar solution.

Blood or menstrual fluid. If the blood is fresh, just rinse it thoroughly in cold (not hot!) water, then wash as usual. If it's on carpet or upholstery, pour a glass of cold water or club soda on it, then blot it with a clean towel.

If the blood is dry, test a section of the fabric with a little bit of household-strength hydrogen peroxide to make sure it doesn't bleach the fabric. If the fabric holds its color, the peroxide should work pretty well at removing the stain. Or, use detergent solution made with cold water, then ammonia solution made with cold water, then sponge with cold water and blot.

Lube. If it's water-based, it should come out during normal cleaning – see "semen" above. If it's oil-based, like Crisco or most hand lotions, sponge it with a small amount of dry cleaning solvent or spot remover and blot it. Then pour and blot the detergent solution. Sponge it with clean water and blot a final time.

Shit. You'll need several different cups of solution here: two of detergent, one of ammonia, one of vinegar. In order, pour and blot: the detergent solution, the ammonia solution, the detergent solution and the vinegar solution. Then sponge with clean water and blot.

Candle wax. Place a rag or washcloth over the spill and iron it with a warm iron. The melted wax will wick up into the cloth, which you can then toss in the laundry for normal cleaning. Some colored candle wax will leave a dye stain – you can try treating this with dry cleaning solvent or spot remover. To be on the safe side, we recommend setting aside an old sheet or cloth to use especially for wax play – place it between your sweetie and your furniture to keep them both happy. (To be extra-safe, try a shower curtain instead – some candle dyes can soak through a single layer of cloth.)

I thought it was a love bite, but I guess I bit down a little harder than I intended...

WE recognize that some people – well, us, actually – get really turned on by biting or being bitten. Skin is pretty durable, so go for it. But be careful... infected human bites are not pretty.

If you haven't broken the skin, treat it like any other bruise (see p. 162). If you've bitten so deeply that there's a lot of blood, apply a clean pressure bandage (a folded towel will do fine) for several minutes. If the wound is gaping open, it will need stitches, and a trip to the emergency room is called for; likewise if you suspect any injury to underlying tendons, muscles or bones. If there's spurting blood, or the bite-ee feels

faint, call 911. If the bite-*er* feels faint, s/he should sit down, head between the legs, and listen to a brief but heartfelt lecture about controlling one's aggressive impulses.

In most cases, though, a through-the-skin bite wound needs treatment mostly to prevent infection. Start by running it under water for a couple of minutes, then wash it thoroughly with soap (antibacterial if you have it) and water. Apply an antiseptic cream if you have any, and bandage it. And, um, you *do* have a current tetanus booster, don't you? (If you don't, get one – you should have one every ten years.)

Human bites are likelier than most wounds to be sources of infection. See a doc for antibiotics if the bite is relatively severe, if it's on your hand, face or genitals (ow!), or if you're diabetic or immunocompromised. And if you see any pus, redness or swelling around the wound, or any red streaks leading away from it, see a doctor right away.

The biter (and possibly the bite-ee, if the biter has open mouth sores or bleeding gums) should refer to p. 148 for information on dealing with exposure to a partner's blood.

I'm pregnant, but I'm not sure who the father is.

YOU'RE definitely not alone: DNA studies by paternity labs across the U.S. show that at least 10% of kids are not the child of the man officially recognized as their father.

Nonetheless, it's a good idea to get this little confusion straightened out early on. Have a talk with all the possible candidates, then arrange for DNA testing – not too expensive and very accurate.

Oh, and fathers: if you find out after the fact that the child you've been fathering is not biologically yours, that's *not* permission to stop being a dad. You are that child's father in every way but the molecular one, and responsible people take care of their children.

Hey, where'd the condom go?

WELL, it was right there on your dick a minute ago…
The first thing you do is tell your partner(s), and enlist his, her or their help in finding it. Odds are it just fell off, and if you search through the bedclothes you'll find it lying there looking up innocently at you. But it might be stuck inside your partner somewhere, most likely in the orifice you were just fucking.

If you can see any part of it in your partner's rectum or vagina, you can probably grab a corner of it and just gently pull it out. It'll stretch, which is fine... just don't let go.

But if it's good and lost – not in the bedclothes, not visible in any hole you've recently occupied – you'll have to go spelunking. Have your partner lie on his or her back, knees spread butterfly-style.

If you suspect the condom is in her vagina, it's probably stuck up behind the cervix. Have her assume the "butterfly" position – on her back, legs up and spread, like at the gynecologist's office. The wider she can spread, the farther up you'll be able to reach.

Reach in with two fingers – lubricated, but not *too* lubricated. (Depending on your safer sex agreements, you might also want to wear a latex glove – although that might make it difficult to feel what you're doing.) Since most women don't like to be poked in this way, she may respond by clamping her muscles down, consciously or unconsciously. Soothing words and a gentle demeanor may help; anything painful will not, even if she usually enjoys that kind of thing.

Her cervix is at the top of the vaginal canal – a firm round protuberance that feels somewhat like a nose. Feel around kind of up, under and behind it (this may be a stretch for your fingers), and you may be able to feel the condom crunched up back there. Try to catch a part of it between your two fingers and gently ease it out. If you can't reach it with two fingers, try to touch it with one finger, wiggling your finger back and forth to dislodge it. If you can coax it out of its hiding place behind the cervix, you can probably get two fingers on it and get it out.

Same directions if it's in the rectum, except there's no end to the canal and no cervix. First, make sure your fingernails are short and smooth, at least on the index and second fingers of your dominant hand. Feel around with two fingers and grab it if you can. If you can't reach it with two fingers, wiggle it around with one and see if you can get it down to where you can get hold of it.

An alternative to the butterfly position for condoms lost in the rectum is to have your partner stand, bent over, and enter from behind (which is probably how you got into this fix in the first place).

If you can't get at it with your fingers, your partner will probably shit it out in the fullness of time. Your partner may choose to take a laxative to speed things up.

If you can't find it, relax – it will undoubtedly turn up at the most embarrassing possible time. A lost condom is a different emergency from a lost vibrator or other sex toy, which we discuss on p. 120.

We've never heard of anyone getting a condom stuck in their throat, but we suppose it could happen, particularly if intoxicants are involved. (Or, we suppose, a child could try to blow a condom up like a balloon and mistakenly swallow or inhale it.) If the condom is blocking the individual's breathing, this is a serious medical emergency. Have the choking victim open their mouth widely; see if you can grab the condom and fish it out. If you can't, call 911 immediately and begin performing the Heimlich maneuver in hopes of dislodging it. If you don't already know how to do the Heimlich maneuver, check the first aid pages at the front of your phone book for quick directions.

A condom stuck in the rectum or vagina is not a medical emergency, but, depending on what you were doing before you lost it, you may have to take steps to protect yourself against disease or pregnancy. Refer to the "condom breakage" advice on p. 126 to find out how to proceed from here.

I was right on the edge... and my vibrator quit. Please, please, please, I want my vibrator back!

THIS is pretty typical of the way electrical toys give up the ghost, says Uncle Abdul, author of *Juice: Electricity for Pleasure and Pain.* (Too bad – we were enjoying the mental picture of showers of sparks flying around the bedroom and lights going out for blocks around.)

"Most commercially made electrical toys are designed very solidly, with excellent insulation," he notes. "If something goes wrong inside, the toy simply stops." You should *not* try to fix it, notes Unc, unless you're a qualified electrician – simply discard it, use your hand for now, and buy a new one soon. In fact, if the toy looks in any way damaged – particularly if the case is cracked, the cord frayed or the plug seriously banged-up or bent – get rid of it. (Yes, we know you paid 100 buckaroos for it. But it was worth it, wasn't it?)

The most common accident Unc has heard of with broken electrical toys involve those vibrating eggs that are attached to a cord with a control box at the end. "People insert the egg into a vagina or anus... then, when they want to take it out, they tug on the cord. The egg comes loose and there they are with both parts of a live electrical wire inside their partner's bodily orifice." This probably isn't *too* dangerous, says Unc, "but you may get a *very* dramatic and startling reaction." (We can just imagine.) To avoid this kind of incident, drop the egg part into a female condom before inserting it and leave the ring at the end of the condom outside your partner's body.

I heard about this guy who got his tongue piercing caught on his girlfriend's clit hood piercing...

PARDON us while we cringe.

And thank you for giving us the opportunity to talk a little bit about the care and feeding of piercings, particularly sexual (nipple and genital) piercings.

Although your friend's experience is, um, unusual, piercings *do* get caught on things – often hair and zippers. If this happens to you, try to avoid putting stretching-type pressure on the piercing. It may be a good idea to recruit a sympathetic friend to help untangle matters. A pair of scissors (many pocket knives contain small ones) can help too.

But if it's too late, and the piercing is already torn, treat it the same way that you would a bite wound (p. 20).

Next, you'll have to decide whether to take the piercing out or to leave it in during the healing process. Piercers will often tell you

to leave the piercing in, but we think that's usually an error: we'd vote for taking it out. You can always re-pierce later, and wounds with foreign bodies in them don't heal as quickly as they should and are more likely to get infected.

In general, we find that piercers are extremely good at piercing and less good at dealing with complications afterwards. If your piercing gets torn or infected, please see a doctor (and if you need help explaining to your doctor why you wanted to pierce *that*, turn to p. 110).

My daughter walked in on my partner and me while we were having sex!

CHILDREN'S sleep patterns often seem supernaturally attuned to adults having sex, don't they? The child who can sleep through the eruption of Mt. Vesuvius will come a-knocking at the sound of sheets rustling three rooms down the hall.

This advice falls firmly into the category of "locking the barn door after the horse is stolen," but tomorrow we want you to go buy a hook latch and install it on the inside of your bedroom door. Not only will it help keep the patter of little footsteps out of your bedroom at inopportune moments, but it will help you relax and enjoy your sex a lot more. If you're involved in BDSM or any other alternative sexual behavior that might look at all violent or frightening to a child, please go take care of this *right this moment* – the rest of this book can wait until you get back.

But if you've already been interrupted by your little darling, it's too late for that now. Most likely, she'll just be curious about what you and your honey are up to. Our own experience (one of us has a couple of kids, the other used to be one) has been that children are able to understand that grownups like to have sex because it feels good. It's better, of course, if you explain this before the occasion arises, so the explanation becomes as simple as, "We were having sex, but we like to do that in private, so please knock next time before you come into our room."

If your child is upset or frightened, of course, you have to stop what you're doing to take care of her – take her back to her bed, tuck her in, and reassure her until she falls asleep. Kids' needs take priority over even the steamiest of sex.

How To Shave Your Genitals

A lot of people try this… once. Most, after a week of insane itching, rashes and/or ingrown hairs, write it off as a youthful experiment and vow never to try it again. But a lot of our friends have developed routines that keep them bare and comfy. (By the way, several of our shaved men friends mention that their hairlessness makes their dicks look longer.) So here's a few tips we've gathered to help your shaving experience go, well, smoothly.

Start by trimming the hair. Use a pair of sharp, smallish scissors, and trim as close to the skin as you can without nicking yourself.

Soften the hair by soaking in a warm tub, or by applying a towel soaked in hot water to the pertinent parts, for about ten minutes.

Apply copious amounts of a good-quality shaving gel or foam. Look for the kind marked "for sensitive skin" (after all, this is about the most sensitive skin you've got). Using plain soap is asking for trouble.

Choose a high-quality safety razor. Disposables don't have a good enough blade, although you can use them if you change them at least two or three times *per shave*. Straight-edge razors are for showoffs (and dangerous to boot). Many of our correspondents recommend the style of blade that has a fine wire wrapped around it to prevent nicking. Consider setting one razor or cartridge aside exclusively for use on your pubes, and keeping a separate one for your legs, pits and/or face.

Stretch the skin taut with one hand and shave with the other. If you're extremely prone to ingrown hairs, shave in the direction of hair growth, but you won't get as smooth a shave that way. Shaving against the grain gives a much closer shave.

If you have to go over the same skin several times, apply more foam or gel as needed. Rinse the blade clean after every couple of strokes.

Rinse off and feel around to see if you've missed any areas. (Take your time and enjoy yourself). On women, the area above the clitoris, where the outer labia come together, is often particularly tricky to get smooth... and particularly irritating when it's stubbly, so pay special attention to this neighborhood. If you want, you can *very carefully* use a tiny amount of depilatory cream on this area only – avoid contact with mucous membranes at all costs.

For post-shave moisturizing, we encountered three schools of thought: one group prefers a moisturizer containing aloe vera, another likes Vitamin E oil from the capsule, and a third likes witch hazel. The really butch ones go for 94 octane

unleaded. We suggest you experiment to see which kind works best for you.

The first time you shave, it *will* itch as it grows back. The skin gets less irritable with practice, though. Most shavers seem to find that repeating every other day is the optimal schedule for staying smooth with minimal itching.

If you find red bumps in the shaved area a day or two later, they're probably ingrown hairs – hairs that have curled up under the skin instead of poking through it the way they're supposed to. Using a clean pair of good-quality tweezers (soak the tips in alcohol first), see if you can tease the hair loose and straighten it out. If the bump is red and irritated, use the tweezers to squeeze it gently. It will open up and the little hair will emerge; trim it with a pair of scissors or pluck it out, doing your best to get the root. To help minimize ingrown hairs, use a loofah or exfoliating sponge to scrub away dead skin cells, and keep the area moisturized.

If shaving still isn't leaving you smooth enough, there are a couple of options to consider. Bikini waxing by a professional isn't cheap and can be pretty painful, especially at first, but it leaves you beautifully smooth for a month or so. Epilady and similar mechanical hair removal devices don't work well on skin as soft as genital tissue. We know one or two really dedicated folks who tweeze their genitals, but we don't have the time or the fortitude and we bet you don't either.

And if you're really dedicated to smoothness, there's always electrolysis (which costs a lot, hurts, and is almost always permanent) or laser hair removal (which costs a lot, doesn't hurt much, and has to be touched up occasionally).

I had sex last night, and this morning I had a herpes outbreak. Could I have infected my partner? What can I do about it?

WELL, yes, you could have. For years, physicians didn't know if someone who wasn't having an outbreak could infect someone. But through the miracle of modern science (yes, really; the viral gene techniques used were breathtakingly sophisticated), they proved that it can happen. Nevertheless, it's relatively rare.

So, yes, it's possible to transmit herpes even when you're not having an outbreak. You can "shed" the virus at any time, although it's certainly more likely, and you'll shed a greater quantity of virus, when you're having an outbreak.

This is why you need to tell all potential partners that you have herpes, and let to them make their own informed decisions about whether or not to have sex with you and what barriers to use. HSV1 is the oral type and HSV2 is the genital type, but you can get

either one in either place. Fifty percent of all adults have been exposed to HSV2, and as many as 75% to HSV1 – so if you don't want to have sex with someone who's ever been exposed to herpes, you may be lonely.

Condoms don't necessarily prevent herpes transmission, since the virus may shed from parts of the body that the condom doesn't cover. Some drugs (Acyclovir, Valcyclovir and Fanciclovir are a few) reduce shedding and can thus help keep you from infecting your partner.

You can take them beforehand to further decrease the possibility of viral shedding – and also to prevent the "friction trauma" of sex (doesn't that sound romantic?) from triggering another attack.

Notify your partner about your outbreak so that they can keep an eye open for symptoms. There's not really all that much else that can be done. Sorry.

Ick – I just found a gray pubic hair!

WELCOME to the wonderful world of middle age, pal. (We've both been here for a few years and it's a lot more fun than you might think.)

Meanwhile, if a distinguished pepper-and-salt pubic patch isn't your look, what to do?

If it's just one or two hairs, we suggest tweezing – a short moment of owww and a long time before it grows back in.

But gray hairs are companionable little suckers, and if one shows up you can bet all its buddies are going to arrive soon. At this point you have three options: living with it, dyeing with it, or shaving the whole mess off, which we explain on p. 33.

Is it safe to dye your pubes? We've never found a dye manufacturer who says so. However, we were able to find a few

people who have experimented with the process and we gathered a few hints to share with you.

First off, stay absolutely clear of any dyes containing peroxide and ammonia, which is most of the stuff you buy over the counter. (And much as we like the thought of you with pansy-purple pubes, the bright-colored punk dyes are meant to be used on peroxide-lightened hair and are thus not a good choice for this area.) Dyes made for men's beards, because they're designed for use on faces, are relatively mild and probably your best bet. Do a patch test first (the package will explain how) on the skin of your inner elbow, and wait 24 hours to see if you develop any redness, itching or rash. If you do, skip the dye job and reach for your razor.

Don't even try to dye the hair around your labia (if you have them) or your anal cleft. Those tissues are too sensitive. If someone's up close enough to notice the gray ones there, you've already got 'em hooked anyway. Stick to dyeing the hair on the front of your pubic mound.

Pubic hair is much coarser than the hair elsewhere on your head or body. It may take a couple of tries to get it the color you want. Wait a day or two between attempts to avoid irritating your skin with repeated applications.

And a final question: is sex with dyed pubic hair Grecian-style sex?

I brought this lady home for sex and I thought we'd had a nice time. But then she started ranting and crying and threatening to commit suicide!

SEX – which is intimate, intense and passionate, at least if you're doing it right – can occasionally precipitate an emotional crisis in someone who's already unstable or vulnerable. Having seen "Fatal Attraction" during an impressionable period in our lives, we decided not to tackle this Disaster ourselves. Marriage and family counselor Dossie Easton, who's spent a lot of time working in crisis centers of various kinds, says:

"When *I* saw 'Fatal Attraction,' I was sitting there in the theater and I just couldn't leave my professional training behind – all I could think was 'For heaven's sake call 911!'"

She adds that if someone's actively trying to hurt himself or herself in your presence, or making suicide threats to you, you've become the projection screen for that person's distress. "You've just become disqualified as that person's helper: they're in tremendous

pain right now, and their requirements for what kind of help they need are probably pretty convoluted, and your involvement makes you the exact wrong person to provide that help." There's a telephone number for your local suicide prevention center in the front of your phone book – she suggests you use it, noting that such centers have both trained phone support and knowledgeable physical support to help your friend, and you, get through this scary situation intact.

This advice is pretty universal if the suicidal person is a stranger or a one-night stand. It could be, however, that a good friend or partner of yours has an emotional meltdown after sex with you. You'll have to decide whether what they need right now is professional help or simply a shoulder to cry on, and act accordingly. If at any time, however, you feel genuinely frightened that your friend may try to harm himself/herself or you, please revert to Plan A above.

My partner says I suck at oral sex.

UMMM... isn't that the idea? Well, never mind. Here are a few suggestions that may help make going down on your partner less of a downer.

First and most important, don't assume that what worked for your last partner will work for this one. Some people like to have sensation focused on one spot, others like it spread out more widely. Some like more pressure, some less. Some want the soft sensation of lips and tongue only, others want the contrast of gently applied teeth... etc., etc. (As a very general rule, men complain that women use too little pressure, and women complain that men use too much. Assume nothing.)

So a good way to start becoming a professional mouth musician is to find out what *this* partner likes. If the two of you are pretty comfortable with frank conversation, sit down during a quiet time

and ask: "I'd really like to get better at giving you the kind of oral sex that you like. Can you give me some ideas about what works for you and what doesn't?"

If one or the other of you is too shy for that, then you'll have to do your research in the field. Stopping briefly from time to time to ask, "Do you like it when I do that?" or "Is this the right place?" or "Harder or softer?" is a good use of your time and tongue.

Once you learn the basic roadmap, vary it. Even the most enthusiastic oral sex recipient can get bored when every blowjob or rugmunch is *exactly* the same as the one before. Try licking the alphabet. Try licking the Cyrillic alphabet. Now do it in capital letters.

And even if you've found that magic spot that's a guaranteed orgasm-producer, don't lunge after it like a dog after a steak. Most people enjoy the sensation of sucking, licking, nibbling, etc., on the surrounding areas – labia, scrotum, inner thighs, etc. A lot of people respond dramatically to oral stimulation of the area around the asshole, using appropriate barriers as needed. (Our favorite analingus barrier trick: take a standard unpowdered latex glove, cut it across the top so that you've removed all the fingers and the rubber between them, and open it down the pinky side. You now have a nice square of latex with a thumb sticking out of the middle. Guess what goes in there?)

If you find that your jaw or tongue tends to get tired before your partner does, there's no reason not to do some calisthenics on your own. If you want to suck cock, suck cucumbers instead. If you want to eat pussy, try hanging an orange from a string and moving it around with your tongue and lips. Also, the use of pillows and

other props to change your and your partner's positions can take a lot of strain off your cheeks, jaws and neck, so experiment.

Fellators and fellatrices, be aware that your gag reflex is a little bit like the "tilt" on a pinball machine – once it's been triggered, it's going to be more easily retriggered for a little while. If you start to gag, stop and do something else for five or ten minutes before you start sucking again.

If ejaculation (of either gender) is on the menu, get clear with your partner beforehand about your policies regarding swallowing. Most ejaculators prefer swallowing, but in our experience very few people will turn down oral sex altogether on that basis. We're not in favor of disappointments in the bedroom, so if you don't like to swallow, say so up front.

And last but not least: just because you went in there with your mouth doesn't mean that the rest of you is out of commission. A favorite of many fellatio fans with TMJ syndrome or easily triggered gag reflexes is to use one's mouth on the head of the penis while stroking the shaft with one's hand. Varying oral sex with sensations from your hands, breasts and other body parts (now *there's* a world of possibilities) gives your jaw a break and gives your partner interesting new feelings.

I just found out I have an STD. Who should I tell and how? And what if I can't find them?

IF you've got an STD, your *first* job is to get treated. While you're at the doctor's office or clinic getting taken care of, find out how long the incubation period is for your disease (e.g., how long after exposure it takes for the symptoms, if any, to show up).

Also, find out how long you might have had it, and what sexual activities can spread it. That way, you've at least got an idea of which people you should be concerned about.

Next, make what the twelve-step folks call a fearless and searching inventory: who have you been messing around with, and how? (If you keep a personal calendar or datebook, use it to remind yourself of dates you scheduled, events you attended, and so on.)

OK, now you've got your list. For each person on that list, you have two questions: Do you think they could have given it to you, and do you think you could have given it to them?

In either case, you're going to have to talk to them – this is basic sexual ethics and if you're not willing to do it we don't want you reading our book. Here's a good way to start:

"Hi, Joe? Tom here. Remember me from Bill's party?... and afterwards we... well, you know. Anyway... some bad news... I woke up this week with [list your symptoms here], and the doctor says I have [whatever your particular affliction might be]. I'm not sure how long I've had it, but you should probably go get checked out just to be on the safe side."

By law, your illness may have to be reported by your doctor to the Department of Health. There's a small chance that they might call you for help in tracking down other possibly infected people. Cooperate. STDs suck – among other things, having an STD can increase the likelihood of transmission of HIV – and sexually ethical people do what they can to help reduce or eliminate them.

And what if you can't find the person? Really can't find them, even after really really trying? (No wussing out.) Well, then there's not really all that much you can do. If your sexual encounter took

place in a sex club or similar venue, there's some chance that the management could help you find the individual in question, so it's certainly worth asking. But this is one good reason to consider exchanging phone numbers or e-mail addresses with casual sex partners if possible, even if they aren't all that cute.

I think my cat ate a used condom.

OUR friend Pat the Vet says: "That's fairly unusual, although not unheard of, for a cat. Cats don't usually eat non-food items... but the one exception is long floppy things that they can play with like a snake, so I guess a condom falls under that category. So do ropes, by the way, so be careful about leaving bondage stuff out where cats can get into it. And dogs, of course, will eat almost anything." (If your pet *does* eat some rope, it's time for a visit to Pat or one of her colleagues.)

Pat says she's never heard of a pet

having gastrointestinal problems after eating a condom, and can find no record of this happening. She suggests that you expect a rather unusual item in the litter box sometime in the next few days, and otherwise don't worry about it.

Every Man's Guide To Menstruation

Menstruation's a little mysterious even to us, and one of us does it and the other one went to medical school to learn about it. But between the two of us, we have a fair amount of information to share... so here goes:

The uterus is about the size and shape of an inverted pear, and lives in a woman's lower belly, below the level of her navel. If she gets pregnant, it's able to stretch and grow to a size capable of holding a newborn infant.

Once a month, an ovum (egg) travels down a fallopian tube from her ovary to her uterus, waiting for a sperm cell to hook up with. Some women can tell when they're ovulating – they get a little feeling of crampiness or irritability, which is technically called *mittelschmerz*, German for "middle pain" – but most can't. Ovulation is her most fertile time, but even she can never be absolutely sure she isn't fertile.

Most of the time the ovum and the sperm don't connect. But just in case they do, every month the uterus builds up an

50

interior cushion of blood and nutrients that could nourish a growing embryo if one showed up. If one doesn't, the uterus sheds this cushion over a period of three to seven days.

On the average, women menstruate once every four weeks – but that's an average. Some do it less often, some more often, and some are wildly irregular. Very irregular menstruation is more typical of women who have just started having periods and of women who are approaching menopause. If the irregularity is a problem, a doctor can prescribe medication to help.

A week to ten days after ovulation, some women begin experiencing sensations that let them know their period is coming. These might include breast tenderness, swollen legs and ankles, moodiness (particularly weepiness or irritability), heightened libido, food cravings, headaches and cramping. What fun!! Some women don't have any problems in this area at all, while others can feel seriously debilitated. Many women get some relief from physical exercise, orgasm, and/or cutting back on caffeine, sugar and salt. (Guess which one the female author of this book prefers.) Queen Victoria reportedly recommended a little herbal cure called "marijuana."

Roughly two weeks after ovulation, her period begins. This usually starts with a small, pink-to-red discharge from her vagina, which she notices when she goes to wipe herself after going to the bathroom. Although it's conventional usage to refer to it as "blood," it's actually a different fluid altogether, with only a small percentage of blood which gives it its color. It can, however, carry blood-borne viruses such as HIV and hepatitis. Most women shed about two tablespoons a day of menstrual fluid.

At this point she will generally begin using some sort of device to protect her clothes from the discharge – usually a tampon, a pad or a cup.

A tampon is an absorbent cylinder of fiber that varies from pinky-size to thumb-size. Most brands come in a tube of cardboard or plastic that she uses to guide it into her vagina, but some have no tube and are inserted with a finger. All come with a string that dangles outside her vagina; when it's time to change the tampon (which she can tell either by guessing that enough time has passed, or by feeling a slight oozing sensation at her labia), she pulls on the string. Some plumbing can handle tampons and some can't – if she doesn't flush it away, she wraps it in some toilet paper and drops it into her wastebasket, where her dog will discover it later and consider it a tasty bedtime snack. (Which always seems creepily cannibalistic to us.)

A pad (or napkin) is the same kind of fiber, formed into an item about as long as your hand and a couple of inches across, with plastic on one side to keep fluid from seeping all the way through – think of a teeny weeny disposable diaper and you've got the general idea. These days almost all pads come with adhesive strips on them, although your authors are both old enough to remember the days when they were attached by their ends to sadistic little elastic belts with metal clasps on the front and back. She sticks the adhesive into the crotch of her panties and wears it there. Pads come in various shapes, absorbencies and sizes. No ordinary plumbing can handle pads, so she has to wrap it in TP or in the plastic wrapper it came in, then throw it away (here, Fido!).

Cups are a relatively new entry into the menstrual protection game. A menstrual cup is made of soft plastic an

inch or two in diameter. She inserts it diaphragm-style over her cervix, where it collects menstrual fluid. When she pulls it out, the fluid flows out of her vagina. The manufacturer tells you to use a new one every time (surprise!), but everybody we know washes them carefully with soap and warm water and uses them several times. Some women report that their cramps are made worse by wearing a cup, but other women love it. You can have mess-free intercourse with the cup in, although you'll probably be able to feel it inside her. Some women also use their diaphragm as a cup, although she should wash it thoroughly a couple of times a day to help prevent toxic shock syndrome.

While she's having her period, she may experience any of the symptoms we talked about during the premenstrual period, but she may especially have cramps. For some women, cramps feel very sharp and acute, like intestinal cramping. For others, they're more of a low, dull, heavy ache, which we suspect may be comparable to blue balls (since one of us has balls and the other one has a uterus, we can't know for sure). Some of the things that can help with mild-to-moderate cramps are exercise, an orgasm (sound familiar?), a heating pad held to the lower belly, over-the-counter medication like ibuprofen, and/or a glass of beer or wine (this last is one your doctor probably won't tell you about, but many women find that it does help). Also, constipation can make cramps worse, so eating a high-fiber diet and drinking plenty of water are good ideas. If her cramps are so severe that none of these make much difference, her doctor can give her something stronger.

Some women have been told it's not safe to have intercourse, take baths, lift heavy items and/or do sports while having their periods. All these activities are perfectly safe. You

may want to be extra-careful with barrier protection while she's menstruating. Some yoga practitioners believe that menstruating women shouldn't do inverted poses, but we've never gotten anyone to explain why.

If she wants to avoid her period and she's on the pill, she can skip the "week off" that's built into most birth-control pills, and she won't get her period that month. Most doctors feel this to be safe, and many women do it occasionally with no ill effects. It is a financial reality for many sex workers.

If she's not on the pill but wants to have sex without making a mess, she can insert her diaphragm beforehand, then douche (this is another prostitute's trick). A small sea-sponge from the cosmetics department, rinsed thoroughly, can also be inserted up by the cervix, where it will absorb the menstrual flow – getting it out afterwards is sometimes tricky, though. (See our instructions for removing lost condoms on p. 23.)

By the way, the female half of this team has heard all the nice theories about menstruation being a woman's time of contact with the Goddess, with her primal self, etc., and how cramps and PMS are patriarchal constructs. She thinks they are bullshit. The male half of the team has learned not to discuss this issue in mixed company.

I walked in on my child having sex.

THIS is a situation for which Dr. Spock did not give you nearly enough guidance.

First and foremost: make sure everyone involved was consenting. If your child wasn't consenting – or is, in your opinion, too young to give meaningful consent – step in and stop the sex, and the relationship, immediately, and call the police if you think that's appropriate. If your child's partner wasn't consenting, stop the sex immediately, get the partner to his or her parents or to an emergency room as needed, and find a competent attorney and an even more competent mental health professional for your kid.

Even if everybody was consenting, there may be legal complications. If one of the people involved isn't of the age of consent in your state, what you just interrupted may have been statutory

rape. If you allow it to continue, you could conceivably be charged with being an accessory.

But let's say this isn't an issue for you. We strongly recommend the taking of deep breaths here. You don't want to frighten or alienate your son or daughter, but neither do you want to be a party to an unwanted pregnancy, an STD transmission or any other Disaster beyond the one you've already got on your hands.

We hope that by this point you've already delivered the Birds And The Bees, 21st Century Version, lecture to your kid. You know – the one about condoms (look at p. 6 for a refresher), birth control, STDs, etc. If not, schedule it immediately. (You might pick up a copy of *The Guide to Getting It On,* from Goofy Foot Press, to give to your child. Maybe another one for your child's partner. Maybe a third one for yourself, if you aren't sure how to do that lecture.)

Next, get your child in to the doctor for an STD check and, if she's female, a PAP smear and some birth control advice. You have the right to insist that any child living under your roof conform to your standards of ethical sexual behavior – which, in our opinion, includes the use of condoms and proper birth control. Many parents of teenagers simply place a large box of condoms in the children's medicine cabinet, check it occasionally to replenish it if the supply is running low, and otherwise ignore it. (If they're giving condoms to their friends, good. You can afford a few rubbers better than a teenager can afford an STD or unwanted pregnancy.)

At this point you've done about all you can do. Make sure this embarrassing situation doesn't happen again by arranging with your child for a suitable privacy signal (the old sock-on-the-doorknob or whatever) – with an agreement that you get to use it too!

She just told me this is going to be her first time. Yikes!

RELAX and breathe deeply. No, not her... *you.*
Introducing a young woman to penetrative sex is an awesome honor and responsibility, and pretty darn scary too. Regardless of whatever physical issues are involved – and we'll discuss those in a moment – please be sure to be as skilled, sensitive and all-around wonderful as you know how to be. Go slowly, make sure she's very very aroused before you even consider trying to penetrate her, and start with a finger or two and maybe a thumb before you plunge in there with anything else.

The hymen is a web or ring of tissue that partly covers the vaginal opening in most young women. A lot of girls manage to break theirs before even considering sex – accidents while horseback riding or on playground equipment have undoubtedly been responsible for the breakage of as many hymens as rum-and-Coke.

And some women's hymens are very small or very easily broken, and won't make much of a difference during first intercourse at all.

But the one of your authors who used to have a hymen had an absolutely terrible time getting rid of hers, and wants you to know how to do a better job of it than any of the young men who were fumbling around her nether regions a few decades ago.

Hymens vary in shape, size and toughness – some are barely noticeable and some are large and tough enough that she's probably had trouble inserting tampons or having pelvic exams. A few may have to be surgically removed (a minor operation that can be completed in a few minutes by a doctor).

If penetration is too painful for her, more force is *not* the answer. Back off, engage in activities to get her more aroused, and proceed more slowly with your fingers; if you can get two fingers and your thumb in without hurting her, you can try next with your cock. If you don't have a cock, be extra-careful – dildos and the like have no nerve endings, so it can be hard to know exactly what you're doing. Holding the dildo in your hand may be a better idea than trying to penetrate her with a strap-on, since it gives you better control.

Some women bleed a lot, others a little, others not at all – it shouldn't be any more than she'd experience in a normal period.

And she might be a bit sore for a day or two.

How about the virgin male? He may not have the same physical barriers, but he's

hoping for a wonderful, memorable first time, too. He may be hypersensitive to comments or teasing. He may come too soon, or be too nervous to get an erection at all. Sensitivity and patience are a good thing with partners of any gender and experience level, but perhaps especially with the young man about to have sex for the first time.

Remember – you only get one chance to make a good first impression!

During sex, my lover started acting really weird – talking in a kid's voice and not responding to questions. I thought he was kidding, but he kept on doing it and it started to freak me out.

GOOD sex sometimes reaches parts of ourselves that we don't get into very often. (No... we mean *emotional* parts of ourselves.) Intense sex, particularly if it has a BDSM, power-exchange or role-play element, can trigger some people into regressing into a childlike state. Good for you for being sensitive enough to notice what was going on with your partner.

At this point what you're doing just stopped being sex. If your sweetie has regressed into a childlike state, explains therapist Dossie Easton, he may not be able to give meaningful consent. "Set your own needs aside and take care of him in the same ways you would take care of an upset or frightened child. Make sure he's warm and comfy, and give him lots of physical nurturing. Don't blame him for what's happened, or try to figure out the problem right now – just

let him know that you care about how he feels and will do your best to give him whatever he needs."

Very rarely, if he doesn't snap out of it after a few hours, it may be time for a little trip bye-bye – to the emergency room to be evaluated. It may turn out that he has a psychiatric problem, a medical problem, or is experiencing a reaction to prescription or nonprescription drugs.

Or, it may turn out that he's just fooling around… in which case you've got a hot little fantasy role-play in your future!

My pussy's still sore from the other night, but that's not the problem. The problem is that now it hurts to pee.

AN itchy, tingling sensation, pain while pissing, feeling like you have to go every two minutes, a generally feverish or shaky feeling, maybe even a tinge of pink in your pee – right?

Well, relax (as best as you can when you feel like you're trying to pee Grape-Nuts™). What you've got is most likely a UTI (urinary tract infection) called cystitis, informally known as "honeymoon cystitis" or "honeymoon bladder" because it so often follows in the wake of really enthusiastic vaginal intercourse.

It's caused by getting bacteria up your urethra, which can happen during sex or in a variety of other ways (although in spite of what your mom told you, there's no proof that wiping yourself front to back will prevent it). You *can* help prevent it by taking a leak soon after you have sex. And, thank heavens, it's easy to cure.

Get in to see a doctor as soon as you reasonably can – this isn't an emergency, but you're probably pretty uncomfortable. In the meantime, drinking a lot of fluids – especially rather acid fluids, such as cranberry juice or lemon water – will help. Take some extra Vitamin C too. And a medication called pyridium (or a similar medication which is available over the counter from the drugstore) will help with the pain as well as turning your urine a pretty shade of pumpkin orange.

Your doctor will prescribe an antibiotic (ask for the inexpensive one – it works fine) which will start to clear up the infection almost immediately. Have a pleasant pee!

Well, *I* thought the two of us were having a great time. But the cop at the front door didn't seem so sure.

TO your average cop, the sound effects generated by a spirited consensual BDSM scene – or, for that matter, even enthusiastic sexual intercourse – don't sound all that different from a domestic violence incident. And domestic violence incidents are notoriously the most dangerous call a police officer can answer. So if a neighbor or passerby has phoned in a complaint about the amount or kind of noise you're making, you can expect a very wary cop at your front door.

We talked to two people to put this Disaster together – our lawyer pal Robyn Friedman, and our cop pal Mike Dulaney. They agree on most points but not on all of them.

Robyn says, "Being calm is how you make sure you don't get shot. Convincing the cop that your play is consensual is how you

make sure you don't get arrested." We think you'll agree that these are both very good ideas.

In many locales, cops have a fair amount of discretion about whether or not to make an arrest under these circumstances; in others, they have a mandatory arrest policy. In either case, you can't go too wrong by being polite, calm and non-inflammatory.

Robyn: "It's always a good idea to set up your scene so that it looks like a scene: candles, music, the toys laid out neatly. Your partner is likely to enjoy this sense of ritual, and it will help reassure the police of the intentional, consensual, safe and sane nature of what you're doing. Try not to set up your scene so that it's visible from the outside of your house – the first thing a cop will do on a possible domestic violence call is try to peek in through the curtains to see what's going on, and if you're, say, peeling red candle wax off your partner with a knife, you're likely to encounter a serious misunderstanding.

"If you're using recreational drugs, put them away when you're done with them, preferably in another room. Keeping a couple of good nonfiction how-to books about bondage or BDSM on hand is a good idea too – they can help serve as evidence that you know what you're doing and care about your partner's well-being."

But now we come to a difference of opinion. Robyn: "Don't keep the cop waiting at the front door as you yell 'Coming, coming!' all the while running around 'sanitizing' your scene by untying your partner or putting away your toys or whatever – the cop will think you're disposing of evidence." Mike: "Take a minute to untie your partner, and for both of you to throw on a robe. Some cops will make an arrest simply because they're homophobic or offended or

shocked by consensual power exchange, and it may be better not to take that chance." (Charles & Janet suggest that some of the difference in opinion here may be because Robyn lives in a relatively sophisticated urban area and Mike lives in the sticks – so your choice in this matter may be affected by the prevailing mores of the area where you live.)

Both Robyn and Mike agree that if you're nervous about the cop seeing what's going on, particularly if you have guns or drugs in plain sight, step outside to talk to him (we'll assume a male cop for the purposes of this discussion), closing the door behind you. Sometimes a statement like "Sorry, we got a little loud – we'll try to keep it down, officer," is all that's required. Be respectful, and be aware that this is one very nervous cop – he doesn't want to get shot or assaulted any more than you do. However, Mike points out that this may not work – if the cop is genuinely concerned that someone's being abused, he'll want to separate the two of you and speak to each of you separately to make sure nobody's being intimidated or coerced.

If the cop wants to come in to see for himself what's going on, let him. You can put your preferences on the record with a statement like, "I'd prefer that you not come inside, but if you insist, you may"; having it on the record that you didn't consent to his entry can be useful if your case ever comes to trial. He doesn't need a warrant if he thinks someone is in danger.

If your partner's still tied up or whatever, allow the cop to speak to him or her if he wants – you might offer to leave the room

while this interview is taking place. Your partner should try to respond intelligently, with a statement like "Hello, officer, is there a problem? I'm sorry if I was making too much noise." This will go a long way toward diffusing any concerns about nonconsent.

If he wants an explanation of what's going on, explain it in terms as non-inflammatory as possible. Don't lie, but don't volunteer information or use inflammatory terminology. Many cops don't have a good awareness of alternative sexual practices, so terms like "SM" or even "kinky" may set off alarm bells for them. "My partner and I enjoy sex in which one of us is tied up," or a statement of that kind, is probably your best bet – and true, too!

I thought he'd consented to everything we did. But the next day he went to the cops and filed assault charges against me.

IF this has already happened to you, you don't need this book; you need an attorney. But there are some ways to help make sure it doesn't.

First, says Robyn-the-lawyer, use common sense. If you're going to do BDSM or sex, choose a partner who seems basically sane, sober and able to take personal responsibility for his or her own choices. Be especially careful if your potential partner is a novice, since inexperienced people may react unpredictably to new kinds of sexuality.

Then, as you set up the scene, save some documentation. If you have e-mails or voice mails in which the two of you discuss activities, limits and safewords, save them on a disk and stash it in a safe place. It may not be a bad idea to set up this date in a semi-public place like a play party or sex club, if possible.

As part of your negotiations, instruct your partner to call or e-mail you the next day to discuss the scene you did together. You can use the message or e-mail as evidence of his or her consent.

What you *don't* want to do: count on a conventional "owner/slave contract," or anything of that ilk, to protect you. Attorneys absolutely love that stuff – unfortunately, the ones who love it most tend to be the *prosecuting* attorneys.

I forgot to take my birth control pill!

WELL, let's see. Today's Wednesday. When was the last time you took your pill?

If it was Monday, so you only missed one pill, take the one you missed right now, today's pill at the appropriate time, and don't worry about it.

If it was Sunday or before, throw away the pills for every day you missed, pick up where you left off (e.g., take Wednesday's pill and go on taking a pill a day till the end of your cycle), and use supplementary birth control (condoms, a diaphragm, or avoiding penis-vagina intercourse) for the rest of the month to prevent unwanted conception.

You know the good part about forgetting your birth control pills? You get a special day of celebration just for you... on the second Sunday of every May.

I'm bleeding from my vagina.

WELL, we hate to ask obvious questions, but... any chance it's your period?

If not, our second guess is that you're spotting. Spotting happens a lot, especially if you're on a new birth control pill prescription – in which case your doc may be able to adjust your prescription to prevent the problem – or if you're coming up on menopause. (The menstrual flow of women approaching menopause often forms clots, which wait until the worst possible time, often days or weeks after you thought your period was over, to make their appearance.)

Obviously, if you're bleeding extremely heavily – say, more than any ordinary menstrual product can handle – you should see your doctor or go to the emergency room immediately. And if you're having other symptoms such as pain, dizziness or nausea, it could

be related to diseases like fibroids or endometriosis, and you should talk to your doctor about it. Otherwise, use a panty shield for a day or two and don't worry about it.

Could you be pregnant? If so, our advice is about the same – but to be on the safe side, call your ob-gyn and ask for instructions. It's probably nothing to worry about, but we want you to feel safe and it's tough to feel safe if you're pregnant and bleeding.

However, let's suppose that you've been having a bit too much fun, and that you're bleeding after rough vaginal play. The rulebook here is basically the same as for rectal bleeding (see p. 102): get to an emergency room if you're having other symptoms, if it doesn't stop after an hour or so, or if you're spurting blood. We are of the firm belief that vaginas come with a warranty and that, properly treated, yours should last a lifetime.

I've risen and I can't get down!

VERY damn funny... until it happens to you. This condition, called "priapism," can be caused by some medical conditions (such as sickle cell anemia) and by some prescription and recreational drugs.

First, try the stuff that helped when you were 14: masturbate to orgasm, distract yourself with unsexy thoughts, take a cold shower. If that doesn't work, head for the ER – an erection that lasts more than four hours is a medical emergency.

Knowing Your Way Around Women's Underwear

We asked a bunch of our friends to describe sex-related activities that seemed so simple that they'd never had the courage to admit they didn't know how to do them. One gentleman friend said, with a slight tone of desperation in his voice, "Could you please explain how to unfasten a damn bra?!"

Like so many seemingly simple queries, this one opened up an entire universe of larger questions. So, based on our experience on the inside and outside of lingerie, a description of how all that stuff works and why women bother with it.

Bras. A bra's basic function is to hold her breasts up and, perhaps, to make them look larger or smaller – it works on the same engineering principle as the suspension bridge. She may want them up for aesthetic reasons (high, perky breasts are a youthfulness signal in women) and/or for comfort reasons (excessive bouncing or sagging *hurts*). She may also want them as a support system for a pair of falsies – for advice on dealing with your disappointment in this matter, see p. 14. Her choice

of bra depends on what she's trying to accomplish and what her body type is.

The standard bra that most of us grew up with consists of two cups, an elastic part that goes around her chest and fastens with hooks in the back, and straps that go over her shoulders, connecting to the cups in front and the elastic part in the back.

Some details about the standard bra. Many of them have c-shaped "underwires" – often actually made of plastic – that go under the breasts to provide greater lift. Some of the newer underwire bras are engineered to lift her breasts extra-high and press them together to make Grand Canyonesque cleavage. Falsies, if she wears them, are shaped like a fat crescent moon and fit under her breasts inside the bra – the classic falsie is made of foam rubber, but more recent "natural" models are made of silicone, or of rubber filled with water.

Curious about sizing? The authority we consulted – a "how to measure your bra size" website – told us that the number is

the circumference of her chest, the letter is the number of inches' difference between the circumference of her chest and the circumference of her breasts at their widest point. (A=1", B=2", etc. The porn star billing of "36GGG" or whatever is hype – bra sizes go up to at least "I," although some manufacturers use "DD" instead of "E.")

If she's wearing a standard back-hooking bra, the eyes of the hooks are on the right side of her body (your left side if you're facing her), and the hooks on the left sidse of her body. Press your middle finger against the eye side. Grasp the hook side between your thumb and index finger and pull towards the eye side. This takes some practice but is a skill worth practicing – although we suggest you practice with very good friends only.

OK, that's the standard. All well and good, until you reach for the hooks and there aren't any.

She isn't trying to mess with your head (probably). Some women prefer bras that hook in front, between the breasts. And if she's going for comfort rather than maximum perk, she may be wearing a sports bra, which doesn't have any hooks at all – it pulls off over her head like a t-shirt. So if you don't find hooks in back, try the front, and if there aren't hooks there either, we suggest you acknowledge defeat and ask her to take it off herself. Or just squeeze the pertinent bits of yourself in between her skin and the fabric.

Some specialty bras don't have straps, or have straps that fasten behind the neck, or have straps that attach to each other before they connect to the back, or go all the way down to her waist, or whatever. Doesn't matter – you've got back fasteners, front fasteners and non-fasteners. Proceed accordingly.

Underpants. These are a bit more straightforward. They're usually made of cotton knit, a synthetic like nylon, or

occasionally (if she likes you very very much) of silk. The cut depends on her own preference and whether she's going for sexiness or comfort. The kind that go all the way up to her waist and cover her entire hip area on the sides are "full cut." If they go up to her waist but are cut higher on her thigh to expose her lower hip and upper thigh, they're "French cut." If the waistband is down below her belly button, they're "bikini cut." If the legs are a bit longer and looser than regular panties, like short shorts, they're "tap pants." If the back part is a little strip of fabric that disappears between her butt cheeks like a permanent wedgie, they're "thong style." (And she may not be wearing them just because she wants to turn you on — many women prefer thongs under close-fitting clothes because they don't leave panty lines that show from the outside.)

What if she wears men's underwear? Some women find briefs or boxers more comfortable than panties, some enjoy them as part of a gender-switching fantasy, and still others probably would rather not have *you*, fella, see them in their underwear.

And what if she doesn't wear any at all? Maybe she wants to turn you on. Maybe she just likes the feeling of a breeze in the bush. Maybe she didn't get around to doing her laundry last night.

Some panties are made with heavy, stretchy fabric that is intended to squeeze away her tummy and love handles. In a less gentle era, these were called "panty girdles"; now, in deference to the tender feelings of aging Boomers, marketers have re-dubbed them "body shapers." If you're trying to get these off her, be prepared to break a nail or two.

If you want to buy her panties, buy the kind she likes. (Check the tag in a pair you see her wear a lot to find out what

her size is – buying either too big or too small is likely to get you into trouble.)

Special Panty Tricks: You can buy cheap ones to cut off her if you and she enjoy that sort of thing. You can even chew them off her, although the nylon gets stuck between your teeth and we really hate that. And, ladies, never underestimate the power of allowing the object of your affections to "accidentally" discover that you're pantiless.

Stockings. Panty hose cover her entire body from waist to toes. Stockings only go up to the middle of her thigh. The kind that are supposed to stay up on their own, and occasionally do, are called "thigh-highs" – they stay up because they've got enough elastic to choke a horse around the top. Regular stockings attach to garters, either as part of a garter belt or attached to a panty gir – er – excuse us – body shaper. There are also crotchless panty hose, which have a hole cut out of the pertinent area, but the one of us who's worn them found that they chafed pretty badly – on the other hand, this might be a different situation on more supermodelesque thighs.

By the way, panty hose and stockings are both fragile and expensive. If you're messing around with her, please be careful not to snag or tear them, and if you do, offer to replace them.

She already knows you prefer stockings and garters to panty hose (unless you're one of those rare panty hose fetishists), so quit whining about it. Stockings and garters are uncomfortable – they chafe around the top, they don't stay put, and the garters make little dents in her thighs. If she's wearing them to please you, we suggest you do something to please her in return – or you're going to be staring at a nylon-clad butt for the rest of your life.

Bigger matters. There's a huge variety of undergarments that cover more of her torso than bras or panties. A few are made as holder-inners – these are another type of "body shaper," and believe us, if you're trying to get her out of one of these, you're going to need her active participation.

Most, however, are made to look hot, and do. A "chemise" is shaped vaguely like a man's undershirt, but made of silky or lacy fabric. A "teddy" is like a chemise, except it goes between her legs, where it may or may not fasten with snaps. (An answer to the question you've never dared ask: if she has to go to the bathroom and there's no snap fastening, she either takes the whole damn thing off, or, more likely, holds the crotch piece out of the way with one hand.) A "body suit" looks like a stretchy blouse, but snaps between her legs. A "bustier" is an elasticized strip of fabric that goes around her breasts and tummy but has no straps. A "merry widow" is sort of a Corset Light – it looks like a corset but doesn't tighten down with laces; it's usually elasticized and fastens with hooks or a zipper up the back.

Corsetry could fill a whole book and is really a much broader topic than we can address thoroughly here. Sooner or later, though, especially if you hang out in goth, kink, or creative anachronism circles, you're going to encounter one. Corsets generally hook up the front with special extra-strong metal hooks. But if hers is as tight as it's designed to be, you won't be able to unhook them until you loosen the laces down the back. These laces start at the top and bottom of the corset, and meet in the middle. To loosen them, untie the middle knot, and loosen upwards from her waist to the top of the corset, then loosen downwards to the bottom. You may have to repeat this process more than once before you get the whole thing

80

loosened enough that you can undo the hooks. Do not loosen it so far that the laces come out of their holes — it's a terrible pain to re-lace it and she won't thank you for it.

If you want to learn to lace her *into* the corset, which we recommend as a very sexy endeavor, get her, or her corsetier, to show you how.

I'm the original "two pumps and a squirt" guy. Is there any way I can last longer?

WHO thinks you're not lasting long enough: you, or your partner? And another question: we all think we know what a "premature" ejaculation is, but what the hell is a "mature" ejaculation?

One of the authors of this book has had sex with a lot of men. That author thinks a lot of men get so hung up on lasting a long time that they last *too* long: "There's nothing drearier than lying there wishing you could go to sleep, while some guy pumps away, dripping sweat on you, in hopes of wringing just one more orgasm out of you." In other words, not everybody you have sex with *wants* you to last longer.

But let's say you really are coming faster than you and your partner want. Some men find that wearing a condom helps delay their ejaculation. We've wondered if there will be a huge epidemic of premature ejaculation – and a crash in the worldwide latex market – after the cure for AIDS is discovered.

Here are some bad ideas: numbing solutions (anything that contains a chemical ending in "-caine" will numb the nerve endings in your dick), masturbating beforehand, thinking about something gross and un-sexy. These are all ways to take some pleasure out of sex. We like the idea of putting *more* pleasure *into* sex.

First off, don't be in such a hurry to stick your cock in there. A slower, mellower pace, enjoying each step of the connection and the foreplay, may put you in a more relaxed mood and take your finger off that hair-trigger.

If you're still finding that two pumps is as long as you can last, then withdraw after one pump. Do something else fun for a while, then go back in and pump again. Continue for as long as you feel like it, then finish off.

Some guys find that focusing *more* intensely on their sensations eventually helps them last longer. By paying close attention to what they're feeling, they learn what sensations drive them over the edge…

so when those sensations come up, they know to switch to another, less stimulating activity for a while.

As you get better at understanding the signals from your body that tell you you're about to come, try the following exercises with your partner on top. As you master each one, try the next one.

- Have your partner masturbate you to the point of coming but not quite over the edge. Repeat, repeat, repeat. When both of you are ready for you to come, take it from there.

- Have your partner insert your penis into his or her vagina or rectum. Then s/he just sits quietly, not moving or flexing any muscles.

- Insert as in the previous exercise... you move, your partner holds still.

- Insert again... partner moves, you hold still.

- Insert again... both of you move.

- Try some other positions.

Try all this over a period of weeks; practice makes perfect. Or, if that seems like too long-term a project, try our favorite solution: go ahead and come. With that out of the way, the two (or more?) of you can settle down for a nice long session of loving sexy play, which may or may not include a second ejaculation for you later on.

Still having problems? Your doctor can prescribe medication to help... and your friendly neighborhood sex therapist has all kinds of useful suggestions as well.

This hickey on my neck is going to be the subject of a *very* interesting discussion with my spouse if I can't figure out a way to get rid of it.

L ET'S start with a talk about your relationship with your spouse, shall we?

If you're doing things that engender hickeys, and you don't want your spouse to know about it, we feel safe in speculating that honesty isn't a core value in your relationship. While we're not your mommies and this is your choice to make, we'd like to suggest that ongoing concealment is hard on you, as well as on your relationships with your spouse and your hickey-giver. We recommend that you consider other options, including fidelity or a consensually open relationship.

But you didn't buy this book for a lecture on sexual ethics, we suppose. So let's talk about that hickey.

A hickey is basically a bunch of broken capillaries under the surface of your skin, caused by a combination of suction and pressure – essentially a shallow surface-level bruise. You can help prevent it by getting ice on the hickified area immediately after you get sucked on, but our experience is that we're rarely that level-headed at such moments. Still, if you can, put an icepack on your neck (or whatever part of you is affected) for 20 minutes, and repeat that every hour for 24 hours.

If the moment got past you and you are definitely marked now, you'll have to cover it up somehow. Turtleneck sweaters can be one option (and if you're in Miami in August, well, serves you right). If you want to try make-up, look for "cream concealer" at the cosmetics counter and try to pick some that's a good match for your skin – if the marked skin is tanned, match the concealer to the back of your hand; if it's not, try the inside of your elbow.

Special Warning: Hot water can bring up marks you thought had faded. Be careful for the next few weeks around showers and hot tubs, or you (and your spouse) may be in for a surprise.

By the way, you kinky folks out there: these same strategies work for welts and shallow bruises. Over-the-counter antihistamines like Benadryl™ can also help fade welts, but they make many people drowsy so be careful.

I just got a call from this woman I had a fling with last month, and she says she's got an STD.

WELL, um, which one? And how does she know she has it – has she been diagnosed by a doctor, or is she just guessing? If she hasn't been professionally tested, both of you can go together.

One good thing to find out is what part of her body is infected, so you can see whether the infected part of her body came in contact with a susceptible part of your body. If she has gonorrhea in her throat but you only had vaginal sex with her, you may be OK. (To get gonorrhea of the throat, you have to do fellatio – cunnilingus doesn't cut it, so to speak.) On the other hand, someone who has an STD in one part of their body may have it in others. So...

Get your nervous body into a doctor's office or an STD clinic. Bring as much information as possible about what your friend has, what kinds of sex you had with her, and any symptoms you might

be experiencing. Don't be offended when the doctor tests you for all the STDs – that's standard operating procedure when someone has been exposed to only one. People with one often turn out to have others.

If it turns out you caught it, you're on the wrong page: turn to "I just found out I have an STD" on page 45.

If you're sexually active (which, since you're reading this book, we assume you are), you should be getting tested for STDs at least every year anyway. You should be checked for syphilis and HIV with blood tests, and gonorrhea and chlamydia with the new urine tests. (You should also be vaccinated against hepatitis A and B, if you haven't been already.) If you're female, make sure your doc does the tests during your yearly PAP – some doctors may assume that you're such a nice girl that nothing like an STD could ever happen to *you*.

Your friend just made sure you've fulfilled this year's ethical obligation. Send her a thank-you note.

It was the best orgasm *ever*. And then there was this blinding headache...

NOT uncommon, really – one of your authors is an occasional sufferer. (You'll have to have sex with both of us to find out which... preferably at the same time.) Head-down positions seem to be a factor for a lot of people.

If this is the first time you've had this problem, you should mention it to your doctor – especially if you're only feeling it on one side of your head.

But assuming it's just your standard-issue post-orgasmic brain-buster... first, stop what you're doing, if you haven't already. Lying down in a dark room will probably help.

Beyond that, here's no one thing that works for everyone. Here are a couple of things that seem to help some people –

- A cup of coffee or another caffeinated beverage
- Some aspirin, acetominophen (Tylenol) or ibuprofen

- A heating pad under the neck
- A spritz of nasal spray containing oxymetazoline hydrochloride (e.g., Afrin). This can help even more if you use it before you come; damned if we know why.
- Your doctor can prescribe other, very effective, medications as well.

We hope one of these helps you – "Not tonight, dear, I'm going to have a headache" is a rotten excuse.

How To Clean Your Sex Toys

For the latest answers on sex toy cleaning, we turned to our pal Frank Strona, founder/director of Scarlet Letter Services and a premier safer-sex educator.

"The easiest way to ensure that your sex toys don't spread viruses is to keep them for yourself only," he notes. "But I'm a harm reductionist and I don't think that's realistic for a lot of us, so my suggestions are based on the likelihood that a given toy will be used on more than one person."

He points out that there are a lot of different substances that you might want to clean off your toys – fecal matter, blood, vaginal fluid, semen and lubricant, just to start with. But here are some good places to start.

If your toy's made of latex or rubber, the safest way to wash it is in your automatic dishwasher on the regular cycle. (Don't use the extra-hot sani-cycle – some rubber toys won't hold up to the heat.) If you don't have a dishwasher, wash it in your sink in the hottest water you can tolerate, wearing latex

or nitrile gloves, and using an antibacterial soap containing triclosan. Then soak it in a solution of one part household chlorine bleach to ten parts cool water for about 20 minutes, then rinse it with plain water.

If the toy is silicone, same thing. Or, since silicone can hold up to more heat than rubber, you can wash the toy and then bake it in a 350º oven for half an hour or so.

"Some toys simply aren't cleanable," Frank notes. "There's no way to clean the string or the junctures on anal beads. The insertable parts of electrical devices typically can't tolerate the levels of moisture or heat needed for good cleaning. Toys with holes are nearly impossible to clean." He suggests keeping these as one-user toys.

When it comes to your SM toys, your cleaning strategy will depend on the material of which the toy is made. For a toy made of non-porous material like plastic or metal, start by washing it with hot water and antibacterial soap to remove any physical debris. Then spray it or soak it with Cavicide®, a hospital-grade disinfectant that's safe around mucous membranes, and let it sit for ten minutes. Rinse it with clean water and let it air-dry.

Leather toys are a more difficult problem. "If the toy's saturated with blood," says Frank, "it's probably best to reserve it as a single-user toy – you'll never get all the fluids back out of it. Just wipe it with a damp rag, let it air dry, and set it aside for the person whose blood is on it."

If there's a small amount of fluid on the toy, your solutions don't have to be quite so drastic. Soak a rag in warm-to-hot water and squeegee it down the surface of the toy. (If you're cleaning a flogger, do each tail separately.) Let it air dry, then retire it for a minimum of 30 days by hanging it in a well-lit

space with good air circulation. Recondition the leather if needed.

The care of wooden and rattan toys depends on whether or not they're varnished. If the toy is varnished, you can treat it as a non-porous toy. If not, you should soak it in bleach/water solution for 20 minutes, then recondition it with linseed oil or whatever your preferred conditioner might be.

Anything intended for urethral insertion needs to be sterilized to hospital standards. Some piercing studios will autoclave your toys for you for a small fee, or you can buy pre-sterilized toys.

Enema gear is difficult to clean efficiently and is thus probably best kept for a single person – most enema stuff is fairly inexpensive anyway. But here's a hot tip from Frank: "If you want an inexpensive and portable enema setup, buy a Fleet™ enema from the drugstore and empty it out – the solution inside it is too harsh for erotic use. Turn the nozzle upside down, inside the bottle, for storage. When you're ready to go, simply fill the bottle with plain water or whatever your preferred enema solution might be and you're all set."

Oh. My. God. My lover just told me she's pregnant.

HMMM. It could be that this is an occasion you've both been working toward for many months, and we hope you had at least as much fun getting there as you're going to have from now on. Pop open a bottle of sparkling cider and celebrate.

But if you're opening a Sex Disasters book to ask about this, we're betting it's not quite that simple. Therapist Dossie Easton recommends that your very first action should be to brew a pot of tea – "because the two of you need to have a loooonnng talk." Spend the time while the tea is brewing settling down and taking a few deep breaths, because now is not the time to panic.

"This feels like a huge deal, but it may not be," she reminds you. "Remember, this happens all the time, and has been happening to people since time immemorial, and every one of them has found a way to deal with it."

She notes that people in this situation often assume that they're going to encounter a huge disagreement, an assumption that may not be warranted. "A good question to start with," she suggests, is 'What do you want to do?' 'What do *I* want to do?' It may turn out that your desires are closer together than you think."

As for what decision you reach… well, we're not about to suggest that in a damn book; we're not that dumb. But we think that if you stay calm, explore all your options, and treat the situation and your partner with respect, whatever decision you make will be the best possible one under the circumstances. And we also think this is a good plan for all kinds of general problems that affect the two (or more) of you.

Owowowowowow! (Vaginal penetration hurts me!)

THIS condition is called dyspareunia, which means "painful intercourse." An old doctor's joke has it that "dyspareunia is better than no pareunia at all," which has one of your authors grumbling humorlessly about institutionalized misogyny and the other one looking nervously away. We don't want anything dys- in our sex lives at all, thank you. Or in yours.

A lot of things can cause dyspareunia, and a lot of doctors don't know much about it. A standard traditional explanation is vaginismus, or involuntary spasm of the vaginal muscles – however, some interesting new research suggests that vaginismus may not exist. (Experienced gynecologists performing pelvic exams couldn't tell the difference when examining women with supposed vaginismus and "non-vaginismus" women.)

Other possible causes include vulvadynia and vulvar vestibulitis, atrophic vaginitis, pelvic vasocongestion, allergies to latex and lubricants, yeast infections, STDs like trichomonas and chlamydia, pelvic inflammatory disease, contact allergies to douching solutions and detergents, razor burn, bowel problems, endometriosis, skin diseases, and a few others that don't even have names.

If this is a new problem, it might be temporary or no big deal. Try a change of position, changing your lubricant or adding more, or simply stopping what you're doing and doing something (or having your partner do something) to get yourself more aroused. If the problem seems to be that whatever your partner is trying to insert into you is too big, back off and go slower, building up over many sessions, using fingers, vegetables, sex toys or a medical instrument.

If this is an ongoing problem for you, it's time for a visit to your doctor, who will want to know where it hurts (your vulva, your cervix, the area behind your cervix?) and what kinds of stimuli cause the pain. He'll do his best to prescribe medication and/or surgery to help, and if he doesn't or can't, find a doctor who will. "Eupareunia" would be "pleasurable intercourse," and that's what we want you to have.

I just found a whole bunch of women's lingerie and bondage gear in my husband's closet.

WELL, you're in for some interesting discussions, anyway.

For help with this thorny issue, we turned to Dossie Easton and Catherine A. Liszt, authors of "When Someone You Love Is Kinky." They note that their advice will come in handy regardless of your partner's gender and orientation, and even the number of your partners – monogamous straight men aren't the only ones who like to get kinky!

The first thing, they say, is to remember that nothing about your partner has changed: he's the same guy you fell in love with and married. He hasn't gone crazy and he isn't some sort of loony out-of-control sex junkie; he just has some sexual interests that are news to you. While you may be feeling pretty freaked out right now, please keep in mind that plenty of couples have encountered

this same situation and have found a way to keep their marriages, and their love for each other, working.

Here are a few options Dossie and Catherine discuss:

- Ask him to stop: "Forget it. Kinky people very rarely come unkinked. And you'll spend a lot of time feeling insecure." And do you really want to live with a frustrated, unhappy person?

- Open up your relationship. This seems like a very big step, maybe even an impossible one. But what you may not realize is that it's not an open-or-shut situation. You can't be a little bit pregnant, but your relationship can be a little bit open. It may turn out that you feel comfortable with letting your sweetie explore his kink only with professionals, or only in your presence, or only without genital contact. If any fluid exchange might be involved, you'll have to make agreements regarding safer sex, and your partner will have to abide by them – this isn't negotiable. But you'd be surprised how many couples have made such arrangements work well for them.

 One thing Dossie and Catherine recommend you *not* do: "Some couples try to make agreements in which A is allowed to see other people but isn't supposed to tell B about it. Our experience is that this kind of arrangement usually winds up with B feeling terrified and insecure, and picturing all sorts of impossibly hot scenarios with impossibly gorgeous partners. If you want to know what you're most afraid of, a 'don't ask, don't

tell' relationship is a good way to find out." A compromise that works for some couples is to agree on a time gap: you tell your partner about your date after a few days, or a week, or whatever timespan feels like a safe enough space to you.

- Try it yourself. Ack! You may never have dreamed of someday holding a whip in your hand, or letting yourself be tied to your bed. But everybody who plays with kinky sex – which we think is about 10% of the adult population – started somewhere, and many of them started because they had a partner who wanted to try it. So why not give it a shot?

 Again, this isn't an either-or proposition – just because your squeeze wants to be dressed up in a maid's uniform and ridden like a rodeo pony doesn't place you under any obligation to do it. The two of you need to sit down together and have a loving, heart-to-heart talk about what each of your desires and limits are. There are plenty of relatively tame, entry-level scenes you can do – a bit of bondage, a taste of spanking, an adventure in each other's underwear – and you may discover that you enjoy such ventures more than you'd imagined. (After all, what do you have to lose?)

There's a lot of good information – books, websites, support groups – for people whose partners are kinky. (The company that publishes this book publishes many other good ones – look on the back page for some ideas.) There's even more information for people who want to explore kink for the first time. And there are therapists

and marriage counselors who can help the two of you come to terms with this news, although you may have to look around a bit for a therapist who's knowledgeable and non-judgmental about sexual activities.

We like your marriage. We hope you do too. And we hope you'll open your mind and your heart to find a way to accommodate this challenging news.

My asshole is bleeding. Should I be worried?

TO get rid of the kind of bloody asshole that calls you up at 2 a.m. to rant about his ex-wife, consider a restraining order. To get rid of the other kind, the answer depends a bit on what you've been up to and what kind of bleeding you're doing.

Anal bleeding may have nothing to do with your sex life. But if you've been doing rough anal penetration, and the bleeding doesn't stop within an hour or so, or if you feel dizzy or lightheaded (well, we guess you're *supposed* to feel a little lightheaded after what you've been up to, but more lightheaded than usual) or are experiencing any abdominal pain, get to an emergency room right away. This could be a serious situation.

Most anal bleeding of less than one or two tablespoons, however, is no big deal. If the blood is bright red, it's probably a hemorrhoid. Unless you're experiencing other symptoms (dizziness

or abdominal pain), don't worry about it. If this is a frequent problem, if you're over 40, or if you have a family history of colon cancer, see your doctor at your convenience. And if you're bothered by itching, pain or bleeding in that area, see your doctor anyway when you get a chance.

If the blood is dark, black, or tarry, it's internal bleeding of some kind. If you're feeling otherwise OK, see a doctor the next day. If you're feeling sick or having other symptoms, go to the emergency room. Avoid aspirin, ibuprofen, naprosyn and any other nonprescription pain medication except acetaminophen (Tylenol) – they can make you bleed more.

Another cause of bleeding can be a diverticulum, a little "pocket" formed in the intestinal wall. Occasionally, one will get irritated or infected and start to bleed copiously. It usually stops on its own within an hour or two, but you should get it looked at anyway. If it doesn't stop by then, or if you're running a fever, in pain or feeling sick, get to an ER.

Bleeding a little bit after you take a crap is nothing unusual and nothing to be worried about, but see your doctor one of these days anyway.

Any kind of rectal bleeding that doesn't stop after a couple of hours is something that a doctor should take a look at. The next day is fine unless you're feeling dizzy, lightheaded, sick...all that stuff we talked about before.

Rrahhharraharrgh. (Translation: I was going down on my girlfriend and my jaw went out of joint.)

THIS is a pretty unusual situation, but it *has* been known to happen. Don't try to push the jaw closed – the jaw joint is a delicate one and you don't want to damage it. Massaging it gently might help. If it doesn't, you'll need a doctor to manipulate it back into place.

More commonly, you could experience jaw soreness or a muscle spasm that makes it hard to open your mouth the day after an enthusiastic blowjob. Rest your face – no bubble gum, sourdough

bread, cunt-lapping or blowjobs (well, you can receive them, just don't give them) until you feel better. Over-the-counter antinflammatory drugs like aspirin or ibuprofen might help, as might a nice massage to the affected area. If ice or heat sound like they'd feel good, try them, too.

To avoid the same problem next time, we recommend experimenting with different positions. Some options for ergonomic oral sex: a pillow under the receiver's butt, a pillow under the giver's head, both of you on your sides with the giver's head on the receiver's thigh, etc.

My ex has pictures and videos of us having sex... and I'm not sure where they might end up.

THE first, and best, suggestion, from our lawyer pal Robyn Friedman: "If you don't want to see yourself plastered all over the Internet, or someday run into someone who tells you how hot you were on the video they rented last night, you may not wish to allow yourself to be involved in potentially compromising pictures or videos." She counsels that this is probably your best option if you have small children – such material can be used against you in a custody hearing – or if your work or life circumstances would create an absolute disaster if those photos were to surface years later.

But if you really like participating in photos or videos (you exhibitionist hussy you!), consider creating a document that spells out exactly how the pictures or video may be used, including a penalty if they are used in any other way. Make sure that everybody participating in the photography signs the document, and consider

keeping it in a safety deposit box for safekeeping. (Robyn reminds you to think of Madonna, whose nude photos surfaced years after she became a major celebrity, and make sure the same thing doesn't happen to you.)

But what if you're already the featured centerpiece of www.suburbantarts.com? "Your case will be treated differently if there's money involved," Robyn says. "If the pictures were sold without your consent, you can go to court and seek an injunction that will stop them from being shown from that point on. You can also sue for a portion of the money."

But since pictures and video proliferate on the Internet like ants in a candy factory, such an injunction may be much too little, much too late. Consider changing your name, dyeing your hair and moving to San Francisco.

She came. She screamed. She passed out.

FAINTING during orgasm, or orgasmic syncope, is one of those things that happens more often in porn than in reality. But it does happen in reality. Usually it's nothing to worry about. But, just to be on the safe side...

Lay the faintee flat on her (for the purposes of discussion we'll assume it's a "her") back. Check to make sure she's breathing and that her heart is beating regularly. If you don't know how to take a pulse, the front pages of your local phone book often have good basic instructions. (And take a good first-aid and CPR class soon, OK?)

If she's not breathing, and/or her pulse is irregular or absent, you've got a full-blown emergency on your hands. *Call 911 immediately.* If you know how to do CPR, get to work.

Another possibility that is quite serious is that she bore down so hard during her orgasm that she raised the blood pressure in her head and burst a blood vessel. If she doesn't regain consciousness quickly, if she vomits, or if she seems weak or uncoordinated (especially if it's only on one side of her body), *call 911.*

However, both of these possibilities are pretty unlikely. If she's breathing and her pulse is regular, leave her alone and she'll come out of it soon. You can speed this process by putting a cold compress on her forehead and nudging her a bit. (You can be forgiven for having a few necrophiliac fantasies while you wait for her to come back.) She'll be cold when she wakes up, so it would be nice to have a blanket ready to wrap her in.

If you know ahead of time that you have a tendency to faint at Those Moments, it's considerate to let your partner know about it – having a partner pull the Sleeping Beauty routine without warning can be pretty upsetting.

How To Talk To Your Doctor About Sex

Well, let's start out by saying that one of us wrote a whole book about this (*Health Care Without Shame*, Charles Moser, Ph.D., M.D., Greenery Press, 1999), and that if you're gay, lesbian, bi, kinky, polyamorous, a swinger, a sex worker, transgendered, or anybody else whose sexuality makes you feel embarrassed to talk to straight doctors, we think you should read it.

But meanwhile, you don't have that book, you have this book. So let's at least get you started with a few hints.

Come out to your doctor before you think you need to. The time to tell your doctor that you enjoy being sodomized with large objects is *not* after the two-liter Coke bottle has gone missing. Give your doctor a chance to learn more about whatever it is you like to do and to voice objections, if any, before something goes wrong. This is only fair, and it's also a way to help ensure that you get informed and non-freaked-out medical care.

Use the least loaded terms you can come up with. It takes a pretty open-minded doctor not to flinch at terms like "cock and ball torture" – try "intense genital stimulation" instead. You might want to think about what you want to tell your doctor, perhaps even making notes to yourself, before you go in for your appointment. Be sensitive to your doctor's reactions and body language as you share this information, and try not to overwhelm him or her with too much information all at once.

Some of the things you might want to discuss:

- Who you have sex with
- What kinds of sex you have with him, her or them
- Your safer-sex precautions and techniques
- Your birth control methods, if any
- Any kinks, fetishes or unusual preferences that could have an effect on your health
- Your drug or alcohol use patterns
- Any unusual family structures or relationships (polyamorous, owner/slave, etc.) which should be taken into account for hospital visitation, decision-making and so on
- Anyone in your family structure who doesn't know about these activities and should be shielded from this information... and anyone *not* in your legal family who *should* get the whole story

If any of the information you need to share with your doctor has to do with illegal activities, such as recreational drug usage or sex work, check with your doctor first to find out what his or her policies are regarding record-keeping on such matters, and then make an informed decision about how you want to handle this communication. We're pretty sure you don't want your preferred brand of rolling papers noted in your chart.

You and your doctor should decide together how often you should be tested for STDs – if you're sexually active, once a year is the minimum. While you're at it, make sure your doc starts you on your course of hepatitis vaccines, OK?

And inevitably, you will find yourself a nice primary care physician who knows all about your weird perverted habits and takes good care of you anyway, then you'll have an emergency, or need to be referred to a specialist, and you'll be back on the exam table looking up at someone who doesn't know anything about your sex life and doesn't want to know. This is where the doc you came out to can help you out – by interfacing with the new person for you, to make sure s/he has all the information s/he needs to give you good and understanding care.

She changed her mind halfway through. Arrrrrrrgggggggghhhh!

ROLL over and bite your fist. Or try a cold shower. If you keep going after your partner says "no" (or, if you've arranged a safeword, after she uses her safeword), you're committing rape, and we don't like you any more.

Don't pester – trying to talk her into it isn't likely to work anyway. But if she's willing to explain her reasons for the change of heart, it may help prevent a repeat next time, if there is a next time. (Same deal regardless of the gender of your partner, of course.)

By the way, if you have sex with someone who's drunk or stoned, their consent isn't legally or

ethically meaningful and so that's rape too. Don't.

And *you* being drunk or stoned is no excuse, either (legally or morally). If you find you need alcohol or drugs to lower your inhibitions enough for sex, we have friends who make a living by talking to people about this.

My boyfriend was doing something reeeallly interesting to my balls – and suddenly I had this *agonizing* pain in my right one and it won't go away.

OK. Unlike broken dick (p. 164), this *is* an emergency. Testicular torsion is a twist in one of the cords that attach your testicles to the rest of you. It cuts off the blood supply to the testicle: if it doesn't get treated, you could lose the ball. Get to the emergency room. The doctor may be able to untwist it manually, or you may need surgery. (Note: This doesn't only happen to perverts like you; heavy lifting can also cause testicular torsion, and sometimes it happens for no discernible reason at all.)

The earth moved. No, it wasn't an orgasm. I mean *the earth moved.*

NEITHER of us has ever been *in flagrante* during a quake – which, given that we both live in San Francisco, probably tells you something about how often we get laid.

So we checked with paramedic/first-aid instructor/sex educator Jay Wiseman. Jay says that the first thing you should do is think about this a bit beforehand, especially if you live in quake country. Check the area around your bed. Are there overhead shelves that could fall down during a quake? (Move them.) How about glass mirrors overhead, you naughty thing, or on the wall nearby? (Replace them with Mylar mirrors.) Is there a large picture window next to your bed? (Hang a heavy curtain over it, and keep it closed when you're in the bed – indulge your exhibitionistic fantasies elsewhere.) Any large piece of furniture, like a bookshelf or armoire, that could tip over onto you? (Bolt it to the wall.)

Jay also suggests adding a few pieces of equipment to your bedroom: a power failure light in an outlet that will help you find your way around if the lights go out, a flashlight nearby, and a good fire extinguisher – Jay recommends a 5-lb. one, rated at least 2A-10BC – near every exit door in your home. Also, if you play with bondage, an important addition to your toybag is a pair of paramedic shears – large, heavy, blunt-nosed scissors that can be used to cut through rope, webbing and other bondage materials quickly in an emergency.

OK, Boy Scout, you're prepared. Now what do you do when the big one actually hits?

"Many of the injuries that happen during a quake come from people panicking and running outside in their bare feet," Jay notes. "In fact, it's pretty rare for structures to fail during a quake, so outside probably isn't where you want to be... and if you *have* to go out there, at least put some shoes on first."

A sensible strategy, Jay notes, is simply to do what you probably feel like doing anyway – just dive under the covers and stay there until the world holds still again, as blankets will protect you and your partner from falling glass or plaster.

If your partner is in bondage, physical protection is more important than getting them loose, at least at first. "This probably isn't the kind of emergency where seconds count," Jay says. "Throw a heavy blanket over the bound person, then climb in there after them. When things calm down a bit, *then* cut them loose and decide together what to do next."

Owowowowowow, part two! (My penis and/or testicles hurt!)

WHERE? And when?

Depending on what you answer, the cause might be...

- infection of your prostate, anus, urethra or testicles
- epididymitis
- blue balls
- a foreskin adhesion
- a skin condition
- herpes
- razor burn
- allergic reactions (see p. 136)
- fractured penis (see p. 164)
- testicular torsion (see p. 115)
- a piercing getting rubbed, chafed or infected

- and probably a bunch of other possibilities we haven't thought of.

Got the picture? Get your dick to the doc so the dick doc can doctor your dick. Some things just can't be covered in a book.

Something is stuck in my butt and I can't get it out.

WELL, before we tell you how to get it out, you're just going to have to sit there – or, more likely, stand there – and listen to a lecture about how not to get stuff stuck in there in the first place.

Anything you put in your butt should have a flange at the end big enough to keep it from getting sucked in there. (If you're a fisting aficionado, your partner's torso qualifies as a large enough flange.) Moreover, because your butthole can do a lot more than you probably think it can, you should have a backup retrieval system on your butt toy, such as a string that stays outside you so that a simple tug will remove the toy. You can poke a hole through the flange and thread a string through it, knotting both ends together to make a loop.

But, if you'd been following those rules, you probably wouldn't be reading this section… right? So, let's see about getting that thing out of there.

First off, let's start with the easy stuff – something that's relatively smooth, not fragile, and inanimate, like a dildo or a chrome egg.

What you *don't* want to do is use artificial means to get it out of there. Don't try to give yourself an enema or use a suppository. Don't try to reach up there with your fingers or an implement to fish it out. You run a real risk of pushing it up there farther, around one of the S-bends that give the sigmoid colon its name, thus reclassifying it from "uncomfortable" to "dangerous."

Instead, try squatting and pushing. If the toy is heavy, don't try this over a toilet bowl – you can break the porcelain. (See our next book, *Plumbing Disasters and How to Survive Them*, for more information on that topic.) You might try putting newspapers on the floor and squatting over them.

If this doesn't work, and if you're not too uncomfortable, be patient. Maybe try the squat-and-push routine again in a few hours. If a day goes by and you're still plugged up, see a doctor. (Don't worry, doctors have seen this problem a thousand times.)

Now, let's suppose you've been just a little bit crazy, and you've put something up there that's fragile and can break into sharp pieces. (Do we need to tell you that this is a very bad idea?) If it's already

broken, call 911 and move as little as possible while you wait for the ambulance to get there – you are in serious, life-threatening danger. If it hasn't broken yet, get to the emergency room, *carefully,* before it breaks.

A special category of the above is things like coke bottles, with holes in the top. These are more dangerous than you might think: the hole can form a suction seal with your innards, so when you try to pull it out, it takes a very precious part of you with it. We don't recommend bottles of any sort as impromptu dildos, but if you must use a bottle, at least stick it in there butt first rather than neck first.

To get it out, *don't* yank at it or twist it. Try rocking it gently back and forth to see if you can break the seal. If you can't, get to an emergency room for help. (You may have to have someone drive you, since sitting in the driver's seat is probably not an option at this point.)

OK, now we come to the one that you probably opened this book to read about: animal life. Yes, we know that the Official Policy is that gerbil play is an urban legend. Maybe so. However, it's a *well-publicized* urban legend… which means that someone has undoubtedly tried it by now. Not you, we hope.

We're not going to comment on the ethics or sanity of sticking rodent life up your butt. We're just going to tell you how to get Mickey or his buddy out of there: he is unlikely to be reassured by sweet talk or gentle music at this point.

The first question is: Does your animal pal have teeth, and is he inclined to use them? If so, don't waste time reading this, get to an emergency room. This situation falls into the same category as sharp broken pieces – your colon is very fragile and very vascular

(well supplied with blood). You do *not* want to take chances on a perforated bowel.

If teeth are not a concern, you may be able to grab a tail, leg or other extremity and gently pull your bewildered little friend out of there.

You'll note that a lot of our advice here involves going to a hospital or an emergency room. What will happen there? Well, the first thing they'll do is go up your butt with an item that's sort of like the birthing forceps obstetricians use, to see if they can gently extract the object without harming you. (Shut up and quit complaining – you *wanted* something in your ass, didn't you?) If they can't get it out safely, you may have to have surgery to remove it. You'll have fun explaining the scar later.

Thanks, doc. Now I've got something stuck in my peehole.

THE urology department in a major California hospital has a Hall of Fame of x-rays of stuff stuck in people's urethras – pencils, toothbrushes, you name it.

If whatever's up there is sharp or breakable, don't spend time reading this, go to an emergency room. But if not...

Try peeing first; maybe you can push it out yourself.

If you can see it, and if you can pull on it, and if pulling is just irritating rather than painful, you can try pulling it out – it'll probably irritate your urethra, but that's not usually a big deal. See your doctor afterwards so that she can take a look

124

at any irritation and decide whether an antibiotic is in order. If pulling is painful or seems to be causing injury, your friendly urologist will need to be paid a visit.

In all cases, this is a time for slow steady pressure, not a quick rip-and-pray maneuver. (We feel a little queasy even writing that sentence.)

And if you can't see it at all, it may have worked its way up into your bladder, in which case you need medical help. When your mother told you always to have a toothbrush with you, this isn't what she meant.

The condom broke. Help!

OK, you're scared. Calm down, please, and keep reading –
this may not be as big a deal as it seems. A lot of abstinence-
only types want you to believe that condoms are as fragile as soap
bubbles and that terrible diseases and pregnancies are inevitable,
which is just not true. A broken condom is an emergency, but it's
not a *huge* emergency.

First, head for the nearest convenient spot and take a leak.
Peeing helps flush fluids and viruses away from places where they
shouldn't be.

Don't douche or take an enema; the solution can push viruses
into any small abrasions in your vagina or rectum. And don't use
chemicals like nonoxynol-9 – recent research has shown them to be
too likely to cause inflammation, so they might make the situation
worse.

Next, sit down and have a talk with your partner. (We'll assume for the purposes of this discussion that he was the one wearing the condom.) Find out whether or not he came. Also, exchange names and phone numbers if you don't already have that information – you're not thinking as clearly as usual right now, and you may find that new questions will come up later.

Examine your partner's penis for rashes, bumps, sores and discharges. Ask him if he's recently had any of these symptoms, or any pain with urination. Your doctor will use this information to figure out the best way to take care of you – you and she may decide to start you on STD treatment right away, or wait to see if you develop any symptoms.

Find out if your partner is HIV-positive. If he is, you'll need to know what medications he's taking, his current CD4 count and viral load, and if he's ever had resistance testing. This information will help your doctor to make decisions about the best course to take in protecting you from contracting the virus.

It's easier to contract HIV (and other STDs) if the condom breaks in your rectum than if it breaks in your vagina. Disease transmission from a broken condom in the mouth is even less likely, and from a condom that breaks outside your body and drops fluids on your skin less likely still (highly improbable, actually).

Whether or not you know your partner to be HIV-positive, visit your doctor or clinic the next day to get tested and to discuss the possibility of HIV prophylaxis. They'll probably want you to come in several more times at intervals of a few months to be retested. If you're clear at the end of six months, you're out of the woods.

If it's possible that you might get pregnant – e.g., you're a fertile woman and you were having vaginal intercourse – visit a doctor or clinic the next day to see if they think it's a good idea for you to take the morning-after pill. These aren't fun, but they work... but they have to be taken within 72 hours, preferably sooner.

If you start to feel like you've got the flu within a few days after a condom failure, call your doctor right away. You've probably just, well, got the flu, but occasionally a primary HIV infection manifests in this way.

And above all, please don't panic. The chances that you've gotten pregnant or contracted a disease are a lot less than the scaremongers would have you think (thank God, if you'll pardon the expression). Good luck!

The first date was OK, but not all that great, and I didn't want to go out with her again. But now I'm getting all these e-mails and phone messages...

AT some point – and it sounds like it might be pretty soon – this sort of behavior will go over the line from mildly flattering attention to intimidation or harassment: in other words, stalking.

Both men and women stalk, and both men and women get stalked. Fortunately, says our lawyer buddy Robyn Friedman, the law takes a dim view of stalking. Under some circumstances (if there's been a previous conviction, or if there's a protective order in place) it's a Class C felony, and the penalties are stiff.

In the state of Washington, says Robyn, stalking is defined as intentionally or repeatedly harassing or following someone in a way that a reasonable person would see as putting the stalkee in fear for their person or property. This is a fairly typical definition for most

states. (The one exception is a licensed private investigator. Weird, huh?)

The first thing to do, she says: tell your stalker clearly to knock it off, and document the fact that you have done so (send a certified letter, or save a copy of the e-mail you send them). At this point, you should also be saving documentation on all stalking behavior. Keep copies of any letters or e-mails, and make a list of the dates, times and places in which the stalker telephones you or confronts you physically.

If the behavior continues after you've asked for it to stop, call the cops and file a complaint. Show them the documentation you've accumulated. They'll help you get this nonsense stopped, with the help of a restraining order if need be.

The Sex Fiend's Health Calendar

For Women

Every Day

For Men

If you're on the pill, take your pill.

Make sure you have enough condoms, birth control pills, lube, contraceptive jelly or foam if you use it, etc.

Examine yourself. Look at yourself naked in a full-length mirror, watching for discharges, lumps, bumps and rashes. If you find anything, you can see your doctor now, or else keep an eye on it for a week or two so you can describe it accurately to your doctor.

Get enough sleep. Eight hours is an average – some people need more, some need less. If you're feeling tired all the time, there may be a reason. Tired people have rotten sex.

Make sure you have enough condoms and lube.

Make sure all your sex toys
are clean and ready for use.
(See p. 92 for cleaning
instructions.)

Eat well. Heavy, fatty foods
slow you down, and we don't
mean in a foot race. HIgh
cholesterol is a risk factor for
sexual dysfunction. Over-
weight is a risk factor for
diabetes mellitus, which is a
risk factor for sexual
dysfunction. And
carrying extra pounds
around is hard on
your heart and hard
on your sex partners.

Don't smoke. Smoking
leads to erectile
dysfunction, impairs
your breathing and
circulation, and you need
those for sex. It makes your
sexual fluids taste bad too.
Besides, who wants to kiss a
smoker? (Not us!)

If you use mood-altering
drugs, including alcohol, do
so in moderation. Intoxicated
people make bad decisions
about sex, partners, and safer
sex. A little relaxation can be

fun and disinhibiting, but more than that isn't good for your relationships or your sexuality.

Look at some art. Beauty is sexy.

Give a hug. Get a hug. Being touched keeps the juices flowing.

Find something to laugh about. Laughter is sexy, too.

Every Week

Are you partnered? Find a reason to make your partner's life special. The old cliché is true – the little things *do* count. And this is true whether you've been together for decades or are just beginning to discover one another.

Do something nice for a stranger. Then, do something nice for a friend.

Don't put off your sexual desires or interests. Place an ad, let your friends know that you're looking... if you want a partner, take the initiative to find one in whatever way works for you.

Do nothing at all. If you can't relax, you can't have good sex. Tension is *so* unsexy.

For Women

Make love to yourself in a new way. Good masturbators make good lovers.

Watch or read some smut.

For Men

Once A Month

Examine your breasts. If you don't know how, the American Cancer Association has materials to teach you.

Make sure you have fresh batteries for all your battery-operated sex toys.

Buy yourself a new sex toy. (It doesn't have to be a $50 number from the erotic boutique – a silk scarf from the thrift store can be a sensual adventure too.)

Examine your testicles. If you don't know how, the American Cancer Association has materials to teach you.

Once A Quarter

If you use Depo-Provera, get your shot. Remember, Depo-Provera and other non-barrier methods don't protect you from STDs.

Get a massage. Give a massage.

Dance. Your body is beautiful.

Ask for something you want. This is an essential sexual skill that also comes in handy a lot of other places.

Once A Year

Get a Pap smear.

If you're past 40, ask your doc if you need a mammogram.

Get an STD check. Depending on what you've been up to, you should be checked for gonorrhea, syphilis, chlamydia and HIV.

If you're past 40, ask your doc if you need a prostate exam.

Check the expiration on your prescription and over-the-counter drugs, condoms, etc., and throw out any that have expired.

Take a romantic vacation – with your partner if you have one; if you don't, go someplace where you can meet new people. If you're broke, take a week off and spend it doing romantic things in your home town.

If you're partnered, sit down with your partner(s) and discuss your goals for the coming year. Remind them of how much they've meant to you in the last year, and how much you're looking forward to their affection and companionship in the year to come. If you're single, sit down and make a list of what you can do in the coming year to help yourself get all the romance, affection and sex you want.

The sex went fine. But now I've got this nasty itchy rash.

WELL, this could be a number of things. Most likely is that you're mildly allergic to either the condoms or the lube. It's less likely, but still possible, that you're allergic to some cosmetic or soap that you or your partner has been using. Or you could just be allergic to sex, in which case you need a lot more help than we can give you in this book.

If you suspect you're allergic to the latex in the condoms (or gloves, or dental dams, or whatever barrier you've been using), switch to a non-latex alternative from now on – mild latex allergies occasionally become more severe, in which case you're in anaphylaxis-land and in serious trouble (see p. 144). If you think the lube is the culprit, try some different lubes, especially some that don't contain nonoxynol-9, a detergent which irritates many people's skin.

Meanwhile, you're still scratching in places that aren't socially acceptable. Start by washing the affected area with mild soap and water, just to get rid of any lingering traces of the allergen. For rashes that aren't on your face or genitals, you can buy cortisone cream and/or diphenhydramine (Benadryl™) cream over the counter that will help get rid of the itching. For itching anywhere, oral diphenhydramine will calm it down, but may also make you pretty drowsy.

If you try all this and you're still rashy after a couple of days, try washing your clothes in hypoallergenic detergent. And if *that* doesn't help, the problem may not be an allergy. It could just be a razor rash or ingrown hairs from your attempts to follow the instructions on p. 33. Or it could be an STD or other ailment such as scabies or lice – get to a clinic or doctor just to be on the safe side.

There were supposed to be three of us in that bed – her, me, and my erection. Only two of us showed up.

AND she probably told you that it happens to all men sometimes, didn't she? Well, she may not be absolutely right – somewhere there's probably some guy who gets erections exactly when he wants them, and we bet he's a real asshole. But in our experience, it happens to just about all men at least once in a while.

Why? Well, some reasons can be medical. A lot of conditions, including diabetes, hypertension and hypothyroidism, can help prevent you from reaching your, um, full potential. So can many of the medications used to treat those conditions.

Other reasons are emotional. If you're stressed, distracted, feeling distant from your partner, or otherwise not on your game, your dick may feel that way too. And let's not forget the effects of drugs, alcohol and/or lack of sleep. It's also generally a good idea to have a partner you want to be with.

Conventional wisdom tells you, "If you ever wake up with an erection, your condition is from an emotional, not a physiological, cause." Well, no (another myth bites the dust). There are plenty of reasons why you might have nocturnal erections but be unable to have one during sex, and not all of them are emotional. And if you *don't* wake up with an erection, that doesn't mean the cause is necessarily physiological, either.

But really, we're not here to second-guess why you're not getting it up – that's a job for you and your doctor and/or your sex therapist. We're here to tell you what to do about it.

Our first suggestion: Who says you have to have intercourse this time? There are a whole lot of ways you and your partner can have absolutely wonderful sex with no erection at all. If you go to your favorite restaurant for dinner, but they just ran out of your favorite dessert, you'd probably consider trying another dessert – such experiences, sometimes called AFOG (Another Fucking Opportunity for Growth... or maybe, in this case, Another Opportunity for Fucking Growth?) can open up whole new horizons.

Most men can orgasm and ejaculate with a soft dick. We bet that your tongue, fingers and other appendages are all behaving just fine. And if you have a spare sex toy or two lying around, so much the better.

But let's say it's an ongoing problem and it's troubling you. What you *don't* want to do is let the problem go on so long that you and your partner get out of the habit of being sexual together – it can be tough to get back into your old patterns again after something like that.

So, here are some options you can try...

Some people find that the use of a cock ring can help. A cock ring helps trap blood in the penis, and also makes a cute bracelet for the fashion-conscious among us. A cock ring costs a couple of bucks – OK, that was the last time *we* bought one; these days they're more like $10-$15 – and can be a fun sex toy even if it doesn't help, so we think this is the best place to start. (See our notes regarding cock rings on p. 1.)

Mechanical devices such as penis pumps can help some men. These work by suction – you insert your cock into a cylinder, pump (think of a bicycle pump in reverse), and the suction draws blood into the penis. You add a cock ring or a special rubber band to the base of the penis and you're good to go. Prescription penis pumps cost several hundred dollars, and the non-prescription ones a bit over $100. But it's a one-time expense, you can sometimes get insurance coverage to help with the expenditure, and many guys find that they're also fun masturbation devices.

There's a little suppository you can tuck down your urethra that can inspire your dick to greater heights. There are also

medications you can inject into the base of your dick (yeep!) that will give you a perfectly lovely hard-on for as long as you need for what you have in mind. They're all prescription-only, of course, but they do work, and we're told that the injection thing isn't really as bad as it sounds once you get used to it. In fact, we know a few folks who'd probably enjoy doing it just for fun.

The last-resort scenario is surgery. Penile implants have gotten much better in recent years – some of the new inflatable ones have worked miracles for their owners.

But none of this is why you turned to this page, we bet. You want to know about the little blue pills, Vitamin V – Viagra®.

Well, you've come to the right place. The author with the letters after his name has lectured and written papers about Viagra and is now going to share all that information with you. The world is just beginning to feel the effects of this new form of "better living through chemistry," and while it may not be a revolution on quite the scale of "the pill" a couple of decades ago, a lot of people's lives are being changed.

Viagra works by blocking the action of the chemical in your body that allows your hard-on to go away. What's important to understand about this is that nothing about Viagra *makes* you get hard – you have to do that on your own. (If you take your Viagra and then read the newspaper for a few hours, you've wasted a pill – unless there's something in the newspaper that turns you on.) You get hard, the Viagra keeps you from getting soft again before you want to.

You should take your Viagra from half an hour to two hours before you expect to need it. You can experiment to find out the

minimum dose that you need to achieve your goal – some men need the full high-dose 100mg, others need 50 or even 25. All the strengths cost the same. Pill-cutter sales have gone through the roof since Viagra became available.

If you are way out of shape, you may need your doctor to clear you for the physical exertion of sex before you try Viagra: having a heart attack while fucking is a fucking bummer (literally).

As the Viagra takes effect, you may feel a headache, upset stomach, a blue tinge to your vision, and/or blurry vision – these are all relatively rare but do happen to some men. It is *very important to avoid* nitrate drugs for 24 hours before and after taking Viagra – they can cause an interaction that can kill you. The only nitrate drug available without a prescription is "poppers" (inhalants used to intensify sex, sometimes sold with weird labels like "video head cleaner"). There are also several prescription drugs that contain nitrates, so it's very important to tell your doctor if you've been taking Viagra, bootleg or prescription – it limits the medicines that she can give you. And if you get an erection that doesn't go away, that's called "priapism" and it's a medical emergency – see p. 74.

New erection drugs are in the works: two similar to Viagra are Vandenafil® and Cialis®, coming soon to a sex doctor near you. Another soon-to-be-released drug called Uprima® (someone made a lot of money thinking up that name) works on a different principle.

The bad news: some doctors won't prescribe Viagra unless your problem is pretty severe, so if you're just having occasional, um, disappointments, you may have to try some of the non-chemical solutions we suggested earlier in this article. And Viagra isn't cheap – here in San Francisco, the going price is $8 per prescribed pill,

much more on the black market. However, many insurance plans will cover it. And come on: you go out and spend $100 on a romantic dinner and you're worried about the cost of a blue pill?!

Things were just starting to get good and he put on the condom... and then all of a sudden he turned red and started wheezing!

A TRICKY situation. On one hand, turning red, heavy breathing and sweatiness can be signs that your partner is very very turned on, which is a Good Thing. They can also be signs of a latex allergy, which is a Bad Thing: latex allergies are real, are getting more and more common, and can be very dangerous. To find out which is going on, you have to ask.

If he's turned on, keep doing what you're doing. If he's allergic, this can be a life-and-death situation. First, get the condom, glove, or whatever other latex item is causing the problem off his body. (Latex allergies can also affect the receptive partner; if this is the case, remove the latex-clad part from whichever orifice it's in.) Depending on the severity of the attack, you can have him take his allergy medicine, take him to the emergency room, or call 911 for an ambulance. If he's having trouble breathing, *call 911 immediately*

– anaphylactic reactions, which is what your partner is having, can kill in a matter of minutes.

Once someone knows they have a serious latex allergy, they can get a prescription for a device called an Epi-Pen that administers a fast injection of epinephrine, which will help control the allergic reaction. If there's no Epi-Pen around, an over-the-counter asthma inhaler containing epinephrine can also help. If the person can still swallow, even over-the-counter diphenhydramine (e.g., Benadryl™ and similar anti-allergy medications) might help.

For people with latex sensitivities, polyurethane condoms and gloves are widely available these days and work very well.

Well, she *said* she was eighteen...

UH-OH. This is not such a good situation.

We did the same thing you might wind up doing: we called a lawyer. (Robyn Friedmann of Seattle, our favorite kinky criminal defense attorney.) She tells us that the first principle here is an ancient and arcane one: don't be a moron. Your one chance of beating a statutory rape rap in most states is if you can prove that you had good reason to believe that your little friend was over 18. (Being served drinks in a bar is not adequate proof – bartenders can be fooled too.) If he or she doesn't look well over the age of consent, ask to see an ID.

By the way, 18 is the age of consent in many states, but not all. In some, there are different ages of consent depending on how old the other party is. In others, the age of consent is different for same-sex sex than for opposite-sex sex (and in still others, you're not allowed to fool around with someone your own sex at all). If you don't know what the age of consent is in your state, find out – there's pretty good information posted on www.ageofconsent.com.

Robyn invokes another ancient and well-known legal principle: no harm, no foul. If nobody reports that you've been fooling around with a teenager (not the teenager himself or herself, not the parents, not the best friend, nobody), then you're safe... though you might want to check out the statue of limitations in your state.

Beyond that, how much trouble you're in depends a lot on what you've been up to. If your partner is under 14, you're pretty much screwed, and we suggest calling a good lawyer right away. If s/he's over 16, you're in much better shape, particularly if you're not too much over 18 yourself. Your troubles may also vary depending on what you've been up to – penetrative sex is likely to be more of a problem than, say, french kissing or fondling. But regardless of age or activity, if things have gotten to the point that a police report has been made or threatened, you need an attorney.

In general, though, we think sex with minors is a Bad Idea. Don't do it.

We were having a great time, and suddenly there was a lot of blood everywhere. After we got done panicking, we realized her period had started.

YOU have three separate concerns here, we bet. First, you may be a little bit (or a lot) grossed out. We can't help you with that one, except to tell you that it's really not all that much blood – most women menstruate something like two tablespoons a day. But when it gets spread around, it can look like one of the less appealing serial-killer flicks, we agree. (If you're blood-phobic and feeling faint, deep breathing and a cold compress on your forehead might help. Leave the mess for clean-up later and go sit down someplace else.)

A bigger concern is that blood can carry some viruses and bacteria that can spread a variety of diseases, and you'll want to protect yourself against those as best you can. If you have blood on you, use a cloth dipped in hydrogen peroxide (the first-aid kind, not the hair-bleaching kind) to clean it off. The peroxide will foam

up but that's nothing to worry about. If there's blood in your mouth, you can also rinse your mouth out and gargle with a solution of half-and-half peroxide and water (ewwww, but it works – don't swallow any, though). If the blood didn't come in contact with open sores on your skin or in your mouth, you're almost certainly fine. If you're still worried, visit a doc or STD clinic the next day, and bring a medical history from your partner. They'll help you decide whether you should be tested and/or given medication to help prevent infection.

And last, of course, you've probably got blood all over the sheets, whatever clothes you might be wearing, your sex toys, etc. See our sections on getting stains out of your stuff on pages 17 and 92.

I was fisting my partner... and now she won't give my fist back!

WE asked our favorite Woman Who Has Had Her Hand In More Women Than We Could Ever Dream Of: Deborah Addington, author of *A Hand in the Bush: The Fine Art of Vaginal Fisting*. And she says...

"You're panting, hot, sweaty, and still rolling on the endorphin sea of her orgasm. Her breathing slows, becomes more regular and her eyes flutter open with a hint of returning consciousness in them. She grunts in lover's language that you should pull your hand out now, which is fine by you; your wrist is at an awkward angle and your fingers have been cramping for a few minutes now, compressed by the intensity of her contractions. You begin to gently uncurl your fingers and start to withdraw your hand, only to hear her make a pain noise because of the suction pulling on her innards.

"You're stuck. Your cramping, torqued hand is stuck in her vagina.

"There's a moment of panic, which you ride through like a champ, not making any sudden moves. There's a moment of awe as you contemplate the strength of her vaginal muscles. Then you remember something you read: 'Don't be alarmed if you start to pull back and find that your fist doesn't seem to want to leave its nice, cozy nest. If that happens, don't try to yank your fist out by pulling harder. Try to hold as still as you can; without the help of her now-spent passion, she's going to feel every little move even more intensely. The contractions that accompany a woman's orgasm are so powerful that her muscles may have created a vacuum around your fist. To gently break the seal, moisten a finger of your free hand and slowly, gently slide it along your wrist into the palm, or along the back of your hand. You won't need to go in very far; you'll know you've broken the seal when you feel the squeeze loosen up a bit. There may even be a small tupperwarish pop. Pull out slowly, asking her for feedback.'

"Because you've been a good fister and educated yourself, you don't panic – you know what to do. You break the seal, and slowly and gently slide your hand out. She even offers to massage it for you. Once you get the feeling back in your fingers, you use your hand to pet and cuddle, snuggle and caress, with a profound respect for her body and a great new anecdote to tell at parties."

Last night I suffered from
[insert sexual dysfunction here].

THIS book includes specific help for some of the commoner problems that come up (or don't) during sex. But we can't possibly list every single sexual dysfunction (pain during sex, lack of sexual desire, inability to orgasm, orgasming before you want to, insufficient lubrication, avoidance of sex...), its symptoms, and suggested strategies for fixing it, all in one little book.

Which is a good thing, because our suggestions for most of them would be pretty much the same. When Part A refuses to cooperate with Activity B, here are some ideas that will probably help:

- Try not to worry. These things happen to everyone (really), and they're usually short in duration. Worrying makes things worse, not better.
- Keep in mind that orgasms don't always happen, and don't always happen when you want them, and that there's no

rulebook that says they have to. There are other ways to feel good besides having an orgasm.

- A good question to ask: "Since I can't provide [whichever activity is problematic right now], what can I do that you would enjoy?"
- Remember that Part A – unless it's your brain – is not necessary for successful sex. Massage each other, kiss each other, caress each other, use your mouth or tongue or fingers on each other, or dig into that marvelous cache of sex toys you've been saving for just such an occasion.
- Forget the physical stuff altogether for now. Lie back and share your sex fantasies with each other. Use your sexiest voice and inflection. Maybe the two of you can try acting out a "radio script" of one of your fantasies, without touching at all. Whew!
- Sleep off the drugs and/or alcohol – a major component in many sexual dysfunctions – and try again in the morning when you're feeling fresher.
- Take a hard objective look at your lifestyle – eating, drinking, stress, sleep, and so on. Leading a sexually healthy life leads to, well, better sex.

OK, you've tried all this, and a month or two have gone by, and you're still having the same [problem]. At this point – sooner if you're having pain during sex – see your doctor and/or your sex therapist. The state of medical/therapeutic knowledge about sexual dysfunction has never been better, so with help and patience, you'll back doing whatever-it-is soon.

**He said I was doing it wrong,
and then he got really angry at
me and I got scared.**

THIS question – which applies to any gender at any time –
may have the shortest answer of any Disaster in this book:
Leave.

"You don't have to make up an excuse, and you don't need to gather up your stuff," says therapist Dossie Easton. "In fact, it's fine to lie if you have to – tell your lover that you're going to get cigarettes, or money, or more booze, or whatever.

"If your lover is acting angry in a way that makes you think he or she might become violent, get out of there now. Period."

She invited her best friend over for a threesome, and I was totally into it. And then things got weird.

THIS is a hot fantasy for a lot of folks of all genders, orientations and relationship statuses. Unfortunately, it's often one of those fantasies for which the phrase "careful what you wish for" seems to have been coined. Threesome participants often seem to reach some moment of truth afterwards that can be summed up as "I did *what?*"

We're not there with you to hold your hand while you're freaking out. But here are a few things of which we can assure you:

- Having had sex with someone of your own gender doesn't mean you're gay. (Likewise, having had sex with someone of the opposite gender doesn't mean you're straight.)
- The fact that you enjoyed it doesn't mean anything except that you enjoyed it.

- The fact that he had a harder erection with the other person than he gets with you doesn't mean anything except that many people are turned on by novelty.
- It is *extremely* unlikely that any one of you is going to leave the person they're with for any of the others of you.

But if you're all that freaked out, the sage advice of two people you've never met isn't likely to help much. If the freakout lasts for more than a few days, or is causing serious ongoing trouble in your relationship, get to an open-minded marriage counselor for help sorting out your feelings.

Every Woman's Guide to Male Sexual Response

It makes a tent pole under the sheets when the alarm goes off in the morning, but when you want it, it's disappeared: erections are tantalizing and frustrating phenomena.

One source we looked at described an erection as a "hemodynamic event," which sounds like a concert promotion to us. The reality is a bit less glamorous, but still fascinatingly complex.

An erotic thought, a sensual touch, or, in the case of some young men, a stiff breeze (hence the technical term "stiffy") can trigger the process. Pure force of will doesn't do much to make erections happen – looking down and saying "Up!" is not a good strategy. Erections also happen spontaneously during REM (rapid eye movement) sleep, which explains the tent-pole phenomenon from the first paragraph.

Nitric oxide is produced by the inside of the penis, in cooperation with the nerves that communicate erotic thoughts to the penis. It starts a cascade of chemical reactions that create

a chemical which causes the smooth muscle in the penis to relax. Voila, an erection. (Viagra® blocks the enzyme that degrades the chemical. See p. 143 for more information about that.)

If you were to dissect a penis (ewww), you'd find three long cylinders inside. The narrow one down the bottom surrounds the urethra, the tube that carries urine and semen out of the body. The other two are fatter, and are made of spongy tissue covered with a tough membrane.

(By the way, our local sex answer line says the question they get asked the most is, "What's the average size of a penis?" The answer: about 5"-7", fully erect. If he's feeling insecure, you can help measure him: get him as hard as you can, or pull his flaccid penis as far away from his body as you can, and measure along the top. And then tell him to quit obsessing about it, because penises are fun to play with regardless of their size – big ones are good for some things, little ones are good for other things, and *his* is good for lots of things.)

Generally, very young men *do* get erections when they *don't* want them, and not-so-young men *don't* get erections when they *do* want them. Very young men get very hard erections that point almost straight up, not-so-young men get less hard erections that point more horizontally, or are even angled downward. This change is caused by stretching of the ligament that holds up the erection. (Gravity sucks.) Another contributor can be deposits of arterial plaque on the inside of the arteries that pump blood into the penis, so taking care of one's heart is also taking care of one's hard-on – which might make that low-fat, low-sodium diet and regular

exercise seem a bit more appealing to him. (For information about erections that won't go away, see p. 74. For information about erections that don't show up when invited, see p. 138.)

Some people think that men need to ejaculate to have an orgasm, or that orgasm results in ejaculation. They're actually separate events which often happen together. Men can have orgasms and ejaculations while they're still soft – a boon to men who have lost their erections to medication, surgery or poor health.

Many men find that with concentration and practice, they can have the sensations of an orgasm without the ejaculation – which means that they can go on having orgasm after orgasm. However, relatively few men seem able to do this without some coaching. The skills are generally taught within spiritual practices like tantra and Healing Tao.

If a penis and its owner receive the right kind of mental and physical stimulation, they will ejaculate. Ejaculation is a reflex – in other words, it just happens. During ejaculation, the sperm moves down from the epididymis (a tangle of tiny tubes at the top of the testicle) and the seminal vesicles, through the prostate gland, where it gets mixed up with other kinds of fluid and expelled through the urethra in pulses. Most men ejaculate about three cc of semen, which really isn't very much (although many of them like to think differently). And, despite many urban legends, it contains almost no calories and very little protein.

Diligent research has been going on in many bedrooms for many years about how to make semen taste better. (It usually tastes salty with a tang of chlorine or copper, and has the approximate consistency of raw egg yolk.) While nobody has come up with the perfect Tas-T-Jizz™ formula, we've heard many people speak well of celery and/or fruit juice as a pre-fellatio

diet. It's universally reported that vegetarians have better-tasting semen than carnivores, and that smokers have the worst-tasting spunk of all. The semen of diabetics often tastes sweet. Most aficionados recommend steering clear of asparagus, onions, garlic and other strongly flavored foods pre-blowjob.

If the urethra is blocked, for example by tight bondage on the cock, the man can have a "retrograde ejaculation" – the semen can't get out, so it gets forced back up the urethra into the bladder and urinated out later. There's no harm in occasional retrograde ejaculations, although most men find them unpleasant.

Once he's had his ejaculation, he'll have a "refractory period" – a length of time during which he cannot get another erection. The refractory period tends to lengthen as the man ages. Many teenage boys have refractory periods that take, oh, about as long as it took you to read this sentence. Elderly men may need a day or so. There are plenty of other fun things to do while you wait.

And now that we've said all this, let us add that both of us think most folks spend way too much time worrying about erections. That's because both of us have found that some of our best times in bed have taken place where there's no erection anywhere in sight. Surely in the 21st century we can all think of more than one way to have sex!

Well, the spanking was fun. But now there's this big swollen black-and-blue bruise that's really scary-looking.

IS the bruise interfering with the way you use the muscle? (Not being able to sit down comfortably doesn't count – we think you probably expected that.) If you can use the muscle, the bruise will fade on its own. Avoid aspirin and other NSAIDs (non-steroidal anti-inflammatories – ibuprofen, naprosyn, etc.) while it heals.

Conventional wisdom has it that you ice the bruise (20 minutes every two hours) for the first 24 hours, then apply heat. We think your body knows best, so if ice feels better than heat or vice versa, go for it.

Some people also swear by bruise plasters from the Asian herbalist's, or arnica from the health food store, to speed healing, but the author with all the letters after his name isn't too impressed by that sort of thing. Still, they're harmless, and they *might* help. If

you really need to get it healed up right away, ultrasound treatment from a physical therapist may help.

If the bruise is interfering with the way you use the muscle, you might have done more damage than you think. It's not an emergency, but get it looked at within the next day or so. See p. 110 for some ideas about how to talk to the doctor about what happened to you.

Well, my girlfriend was on top... and suddenly there was this snapping sound and YEOWW! And now my dick is black and blue, and hanging crooked. Doc, will I ever play the violin again?

YIKES! Oh, pardon us... what we meant to say was "Hmmm."

A doctor will call this phenomenon "rupture of the tunica albuginea," or, if he's feeling informal, "fracture of the penis"; anybody else will call it "broken dick." It doesn't happen often, but all it takes is once to spoil a nice evening.

Technically, here's what happened. The inside of your penis contains three long narrow "bags" filled with spongy tissue. When something very very nice is happening, more blood goes into the penis than can flow out... the muscles at the base of the penis tighten... and the pressure inside the penis goes up. The medical term for this is a "chubby."

The tough membrane covering these bags of blood-engorged tissue is called the tunica albuginea. Occasionally, too much force

in the wrong direction will rupture this membrane, and the blood will escape from the spongy tissue into the rest of your dick – sort of like a pail of water with a hole in it. You'll probably feel pretty intense pain, you'll definitely see a big bruise and a bend in your penis, and you'll most definitely feel absolutely terrified.

This may feel like an emergency, but it really isn't. Put an icebag on your dick (brrr!) – the usual icebag routine, 20 minutes on, 40 minutes off, repeat as needed. See a doctor the next day. Obviously, if the pain is severe, other symptoms are present, you're taking anticoagulants ("blood thinners"), or you have other medical problems, get to your doctor or the emergency room right awy.

Most doctors prefer to repair the break surgically, but some new evidence suggests that this problem can often heal itself up just fine. Let your doc, and your dick, be your guides.

See that door? It's locked from the inside. And my sweetie is in bondage on the other side of it.

OUR friend Mike Dulaney is the guy you wish you knew right now: a sex-positive deputy sheriff who's a part-time locksmith. He took a few minutes out of what must be an awfully busy day to brief us on the things you need to know when locks and sex happen in the same place. (His first hint: anytime you're having sex and there's a lock involved, have an extra key around somewhere.)

"The locks on most interior doors are pretty straightforward and easy to spring," he comments. "You can often just slip a straightened-out paper clip or a small screwdriver into the hole in the doorknob. Try pushing it in, or maybe pushing it and turning it, and the lock will snap open." Failing that, the old credit-card trick should work – he suggests prying the trim away from the doorframe a little bit with a kitchen knife, then sliding the card into the gap to push the lock open.

But if you like locking your partner up with padlocks and handcuffs and such, it gets more complicated. "If you're into padlocks, please buy them all keyed alike," he suggests. "If you want more later, go back to the same locksmith and they can order you more with the same key. You can keep extra keys on your personal keyring, in your junk drawer, hanging on a hook – anywhere that *isn't* where you're having sex." He also recommends that chain and lock fetishists invest in a set of good bolt-cutters ("waste a link of chain or a spare padlock to make sure they actually work") and a hacksaw with a good blade.

Mike also sensibly recommends that you keep all your handcuffs and padlocks locked when you store them – that way you know you have the right key and that the locks are working OK.

The commonest handcuff disaster, he tells us, is a key breaking off in a handcuff. "But that usually only happens on one cuff – you can use your spare key to get them out of the other one, so at least they can move freely and comfortably while you figure out what to do next." If the jammed cuff isn't yet double-locked, there's a very small chance you can spring it – slip a thin flat piece of spring steel into the cuff between the serrated teeth of the pivoting portion and the locking mechanism. As you slowly tighten the cuff down one notch, see if you can wiggle it around and spring it loose. If that fails, reach for the hacksaw (Mike mentions that a Dremel tool with a small cutting wheel also works well, but the handcuff will get very hot). Or reach for the telephone to dial your friendly neighborhood locksmith, who will have a nice story to tell his wife that night.

167

Appendix: The Big Bad Disasters

WE'VE had fun writing this book, and we hope you've had fun reading it. But as a result, we haven't really had an opportunity to talk about the kind of disasters that aren't even slightly entertaining: rape, assault and child molestation. So here's some entirely serious information about what to do in situations like these.

If you've been raped, and you think there's any chance that you may want to have your rapist arrested and prosecuted, *do not bathe* or otherwise clean yourself – if you do, you'll be destroying evidence that could help put your rapist behind bars. Many communities have rape crisis hotlines with trained staff to help you deal with the physical, emotional and legal aftermath of what's happened to you. If you think you might want to prosecute your rapist, or if you think you might have been injured, go to the

emergency room, possibly with a rape crisis counselor, friend or partner as a support person.

While most rape crisis centers and emergency rooms are most familiar with female rape victims, they are well aware that men also get raped, and may be able to help you regardless of your gender or orientation. They may refer you to resources for male victims of sexual assault in your area.

If you've been battered, abused or assaulted by a partner or spouse, there is a shelter for battered women in your area – federal law mandates that there must be at least one in every community. Call them for help. Although they're generally set up to help women who have been battered by male partners, they may be able to refer you to resources for gay or lesbian abuse victims, or for men who have been abused by female partners, in your area. Also, if you have abused your partner, or are worried that you might, they can refer you to groups that can help you learn more appropriate ways to deal with your relationship issues and emotions.

If you are aware of a child who is being sexually molested or abused, the federal Administration for Children and Families says: "You should call your local Child Protective Services (CPS) agency or the CPS agency in the State in which the abuse occurred. Not every State has a toll free hotline, or the hotline may not operate on a 24 hour basis. If a toll free (800 or 888) number is available, it may be accessible only from within that state. If you need to report suspected abuse in a state other than your own, please call Childhelp's National Child Abuse Hotline at 800-4-A-CHILD (800-422-4453)."

We hope you never need any of the advice in this Appendix.

Contributors

CHARLES MOSER received his Ph.D. from the Institute for Advanced Study in Human Sexuality and his M.D. from Hahnemann University School of Medicine in Philadelphia. He is board-certified in Internal Medicine and is also a board-certified Sexologist. He maintains a private internal medicine practice in San Francisco, with a focus on sexual concerns and the medical problems of sexual minorities. He has published numerous academic papers on sexual topics, including nipple piercing, sadomasochism, safer sex, orgasm, the effects of recreational drugs on sexual functioning, and is the author of "Health Care Without Shame: A Handbook for the Sexually Diverse and Their Caregivers."

JANET W. HARDY is an author and educator specializing in alternative sexual concerns. She has spoken in academic, media and

social settings nationwide on topics including erotic dominance, spanking and polyamory. Under the pen name "Catherine A. Liszt," she is the co-author of "The Ethical Slut," "The Bottoming Book," "The Topping Book" and "When Someone You Love Is Kinky"; under the pen name "Lady Green," she is the author of "The Sexually Dominant Woman," "The Compleat Spanker" and "KinkyCrafts."

DEBORAH ADDINGTON has degrees in both English and Women's Studies. She wrote "A Hand in the Bush: The Fine Art of Vaginal Fisting" because she wanted to bring fisting out of the closet, where she feels no consensual sexual act should be. She lives at the extreme northern end of California but tries nonetheless to maintain her sanity and her pervertedness.

MIKE DULANEY is a Deputy Sheriff in a rural area of the Rocky Mountains. He has been locksmithing for 27 years and in law enforcement almost as long.

ROBYN FRIEDMAN is a Criminal Defense Attorney currently living in Seattle, Washington. She has been part of the SM/Leather/Fetish Community for several years. Her local involvement includes holding low-cost legal clinics to provide community members with important legal documents, such as Durable Power of Attorney and Health Care Directives, as well as legal services at reduced rates. She is also on staff with The National Coalition for Sexual Freedom as a presenter/speaker on SM and legal issues for various groups and organizations, as well as at local and national events and conferences.

JAMES KOCHALKA is not just a prolific cartoonist, he also sings in his own band, "James Kochalka Superstar." His main

character, whom he sometimes uses for autobiographical purposes, is Magic Boy, a small elf with pointy ears. Critics and fans alike enjoy his ubiquitous and instantly recognizable one-pagers in comics and magazines, and his graphic novels like "Paradise Sucks" and "Tiny Bubbles." He sometimes works with cartoonist Tom Hart, with whom he created "Monica's Story," an adaptation of the Starr report.

PAT THE VET, DVM, has enjoyed seeing a wide variety of pets and their owners during her California practice years. She keeps saying nothing will surprise her... and then someone does.

FRANK STRONA is Founder/Director of Scarlet Letter Services, whose focus is on improving sexual expression in all forms. Frank has presented workshops on subjects ranging from SM burnout and body awareness topics to Substance Abuse Recovery to HIV/STI Harm reductions strategies. He is a specialty educator and contracts with state and federal agencies seeking to reach hard to access populations. He travels nationally and internationally presenting workshops on the importance of increased information on improving sexuality, harm reduction and HIV education and has specialized in customized programs dealing with SM relationships, theory, and techniques to men and women one-on-one, in couples, and in groups. Frank has dedicated his life to mentoring men and women in topics like intimacy, breaking taboos and fear, boundaries, communication, fetishes, dating, sex parties, and monogamy. Frank can be reached through *http://www.mentorsf.com.*

UNCLE ABDUL is the *nom de plume* of an electrical engineer with more than 33 years of experience in the issues of electrical

safety with the sexual community for 22 years. Author of "Juice: Electricity for Pleasure and Pain," Unc is a firm believer in achieving SAFETY through UNDERSTANDING.

JAY WISEMAN is a nationally respected alternative sexuality author, educator, mentor, workshop leader, expert witness, and activist. His books include "SM 101: A Realistic Introduction," "Jay Wiseman's Erotic Bondage Handbook," and "Tricks... To Please A Woman." A former ambulance crewman with years of experience, and holder of one of the highest awards for lifesaving action, Jay also teaches classes in basic and advanced emergency medical care for sex clubs and other groups.

Other Books from Greenery Press

GENERAL SEXUALITY

Big Big Love: A Sourcebook on Sex for
People of Size & Those Who Love Them
Hanne Blank $15.95

The Bride Wore Black Leather... And He
Looked Fabulous!: An Etiquette Guide for
the Rest of Us
Andrew Campbell $11.95

The Ethical Slut: A Guide to Infinite Sexual
Possibilities
D. Easton & C.A. Liszt $16.95

A Hand in the Bush: The Fine Art of
Vaginal Fisting
Deborah Addington $13.95

Health Care Without Shame: A Handbook
for the Sexually Diverse & Their Caregivers
Charles Moser, Ph.D., M.D. $11.95

The Lazy Crossdresser
Charles Anders $13.95

Look Into My Eyes: How to Use Hypnosis
to Bring Out the Best in Your Sex Life
Peter Masters $16.95

Supermarket Tricks: More than 125 Ways
to Improvise Good Sex
Jay Wiseman $11.95

Turning Pro: A Guide to Sex Work for the
Ambitious and the Intrigued
Magdalene Meretrix $16.95

When Someone You Love Is Kinky
D. Easton & C.A. Liszt $15.95

BDSM/KINK

The Bullwhip Book
Andrew Conway $11.95

A Charm School for Sissy Maids
Mistress Lorelei $11.95

The Compleat Spanker
Lady Green $12.95

Family Jewels: A Guide to Male Genital Play
and Torment
Hardy Haberman $12.95

Flogging
Joseph W. Bean $11.95

Jay Wiseman's Erotic Bondage Handbook
Jay Wiseman $16.95

The Loving Dominant
John Warren $16.95

Miss Abernathy's Concise Slave Training
Manual
Christina Abernathy $11.95

The Mistress Manual: The Good Girl's
Guide to Female Dominance
Mistress Lorelei $16.95

The New Bottoming Book
D. Easton & J.W. Hardy $14.95

The Sexually Dominant Woman: A
Workbook for Nervous Beginners
Lady Green $11.95

The Topping Book: Or, Getting Good At
Being Bad
D. Easton & C. A. Liszt $11.95

FICTION FROM GRASS STAIN PRESS

The 43rd Mistress: A Sensual Odyssey
Grant Antrews $11.95

Haughty Spirit
Sharon Green $11.95

Justice and Other Short Erotic Tales
Tammy Jo Eckhart $11.95

Love, Sal: letters from a boy in The City
Sal Iacopelli, ill. Phil Foglio $13.95

Murder At Roissy
John Warren $11.95

The Warrior Within (part 1 of the Terrilian
series)
Sharon Green $11.95

The Warrior Enchained (part 2 of the
Terrilian series)
Sharon Green $11.95

*Please include $3 for first book and $1 for each additional book to cover shipping and
handling costs, plus $10 for overseas orders. VISA/MC accepted. Order from:*

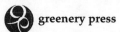 greenery press

*1447 Park St., Emeryville, CA 94608
toll-free 888/944-4434 http://www.greenerypress.com*